IMAGES
of America

SEABROOK

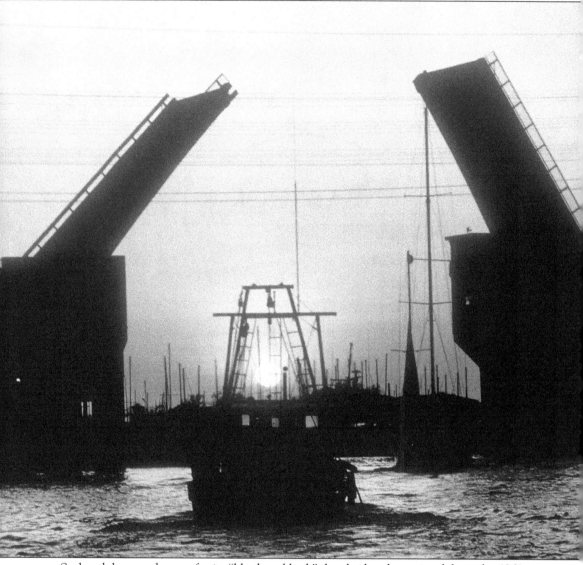

Seabrook became known for its "blankety-blank" drawbridge that existed from the 1960s into the 1980s. The area grew too fast for the motorist and boating traffic that regularly came to a halt when the bridge was either up or down. (Photograph by Ruth Burke.)

ON THE COVER: In 1966, when this photograph was taken, the Seabrook waterfront was a prime location for the commercial fishing industry. With the demand for tasty Gulf shrimp and oysters growing in the United States, the fertile waters of Galveston Bay and easy access from Seabrook provided a successful living for the commercial fishermen in the area. Seabrook became known as—and is still—the popular place to purchase fresh seafood from the boats. (Courtesy Louis Muecke Family Collection.)

IMAGES
of America

SEABROOK

Ruth Burke and Don Holbrook

ARCADIA
PUBLISHING

Published by Arcadia Publishing
Charleston, South Carolina

Library of Congress Control Number: 2010927858

For all general information, please contact Arcadia Publishing:
Telephone 843-853-2070
Fax 843-853-0044
E-mail sales@arcadiapublishing.com
For customer service and orders:
Toll-Free 1-888-313-2665

Visit us on the Internet at www.arcadiapublishing.com

*We dedicate this book to the people of Seabrook,
past and present, who have shared the job of rebuilding
their community and homes after a hurricane.*

CONTENTS

ACKNOWLEDGMENTS

We would very much like to thank the many longtime residents of Seabrook for helping us gather information and photographs that became part of this book. Without the diligent efforts of Greg Burns, the librarian of the Evelyn Meador Library, locating the historic photographs of Seabrook that were put in storage after Hurricane Ike, many of the older photographs would not be in this book. We thank the Friends of Evelyn Meador Library, noted EML in the book, for gathering these photographs that record the history of Seabrook. We thank the City of Seabrook, NASA, Sally E. Autrobus, and Sue Harral and the authors of articles from the *A Day At The Bay*, published by the Seabrook Association, for helping with historic facts and obtaining photographs. The Lakewood Yacht Club (noted LYC in the book) has been generous in contributing photographs from their 50th anniversary book. We also thank Louis Muecke's daughters, Lynda Porras, Nancy Smith, Patsy Watkins, and Glenda Cox, for contributing the photograph that is the cover of this book and those noted in the book.

As coauthor, I, Ruth Burke, am honored to be able to share my images that I have photographed in Seabrook for this book. When I came to Seabrook in 1974, I was drawn to the unique character of the waterfront and its unspoiled coastal beauty. This started my career in photography and fueled my interest in being a part of the business community. The people of Seabrook loved their place and they liked what I saw when I photographed it. I thank them for their support and giving me the courage to expand on my talent. I opened my first gallery in 1989 and through my published photographs, I have shared Seabrook with the world.

This book contains many photographs by coauthor Ruth Burke and from her collection, although without the generous donations by those noted, this book would not be possible.

Coauthor Don Holbrook has been a driving force in making this book happen. Although this book is by no means a complete representation of all aspects of life in Seabrook, together, we have worked to present the diverse character of Seabrook in photographs.

Introduction

The beauty of the lush green coastline of Clear Lake as it feeds into Galveston Bay through the Clear Creek Channel has been home to civilizations for centuries. The land that is currently known as Seabrook, Texas, was first the home of the Attakapas, Karankawas, and Cohuiltecan Indian tribes. Sandbars and shell reefs extended far out into Galveston Bay. They fished the local waters, feasting on fish, turtles, and alligators. The location of Pine Gulley Park in Seabrook is a historical site, with shell middens where the Native Americans set up camp.

The 1800s witnessed visits of Jean Lafitte, a Frenchman and pirate. The Karankawa Indians were a nuisance to him, and he referred to them as "demons from hell." He mounted an all-out campaign to eradicate the fierce warriors from the Galveston Bay area. By 1850, most of the Native Americans that roamed the Texas Gulf Coast had vanished due in large part to being victims of wars and European diseases, such as smallpox and chicken pox. By 1908, only nine Attakapas were alive, and all the other tribes were considered extinct. Legend has it that when Jean Lafitte took his loot and traveled up the Clear Creek Channel into Clear Lake, he was searching for a hiding place for his treasure. He was believed to have traveled on into Mexico but some of his men stayed and settled in the area around Seabrook. As shown on the Seabrook land plot from the late 1800s, the channel made an S curve before entering Clear Lake, thus, providing a secluded hideaway for his men, ships, and treasure.

At one time, the Peden Estate, a beautiful 250-acre summer estate located on Clear Lake and Taylor Bayou in the 1920s, was part of the Morris land grant that became known as Morris Cove and then Seabrook. This estate claimed fame to numerous legends and traditions about rare jewels, Spanish doubloons, and precious stones being buried there after having been seized by the pirate crews of Jean Lafitte on the high seas. One of Lafitte's men, named Taylor, owned a log cabin in the area. He was a hunter and fisher for Lafitte in the region, thus, Taylor Bayou was named after him. Sisters Ada M. Goodrich and Mrs. Bob Larabee (granddaughters of Ritson Morris) related in an article that appeared in the May 16, 1926, issue of the *Houston Post* that "as girls we would find objects around the place, which we were told were relics of Lafitte." A widely told treasure story told by the Morris granddaughters is "about a seaman from the North [who] came down to this country and became friendly with one of Lafitte's pirates. The pirate fell ill, and the northern man doctored him and took care of him. The pirate died, but before his death he told the northern man he was going to reward him. The pirate drew a map of Clear Lake, showing the Morris Place, and the house. 'Follow this map,' said the pirate. 'Dig deep under the elm tree, at the spot I have marked, and you will find a fortune.' They dug and dug at the exact spot indicated but found no treasure . . . grandfather used to talk of it, and he expressed the theory that the treasure chest happened to be buried in one of those sand strata which they shift and move and thus was carried farther from the tree, toward the lake." Much of the treasure lore is noted to be in the vicinity of where Lakewood Yacht Club is currently located.

After the pirates and Native Americans came the pioneers. In 1829, Amos Edwards moved from Nacogdoches to live in Stephen F. Austin's colony on Galveston Bay (the site he had chosen was Davis Point, on what is known today as San Leon, Texas). In 1830, Edwards moved northward, up Galveston Bay, purchasing land north of Clear Creek from Anson Taylor (reputed cohort of

Jean Lafitte) for his son-in-law Ritson Morris, a young lawyer from Virginia. On November 14, 1832, Ritson Morris was granted one league of land from the Mexican government at the site that later become Seabrook. He built a home for his wife, Minerva, and their daughter, Virginia, in the area along Galveston Bay, north of the Clear Creek Channel. The home was named Elmwood Plantation and was beautifully situated in a long-sweeping crescent of the bay between Edwards Point and Red Bluff. Morris raised cattle, chickens, horses, and hogs on the plantation. The 1840 tax list of Harris County enumerated 150 cattle, 15 horses, 6 slaves, and title to 3,600 acres of land for the Morris family. As other settlers joined him, the area became known as Morris Cove. A Ritson Morris/Elmwood Plantation historical marker has been placed by the State of Texas near Seabrook's Evelyn Meador Library. Legend has it that some time after the Battle of San Jacinto, a number of men rode up to the Morris home with a Mexican prisoner. Morris fed them and let them stay the night. It was later learned that this prisoner may have been Santa Anna, who was captured at the battle and was taken to Freeport under Gen. Sam Houston's orders.

Toward the end of the 19th century, the Southern Pacific built a railroad from Galveston to Houston, routing it around the bay shore area. This created a development opportunity that spiked the interest of John Seabrook Syndor, a businessman and former mayor of Galveston, Texas. He saw the potential for wealthy Houstonians to have summer homes on the bay with easy access by train. Planning this as a business for his son, Seabrook, he purchased 263.3 acres for $35 per acre in May 1895. Seabrook Syndor grew up in the Powhatan House located at 4327 Avenue O in Galveston, a beautiful example of Greek Revival architecture. He married a well-known member of Houston society, Ella Hutchins. Seabrook Syndor formed the Seabrook Town Lot and Improvement Company and, along with E. N. Nicholson and E. S. Nicholson, platted the town that now bears his name. Wealthy Houstonians begin building summer cottages in the town, and a special commuter train called the *Suburban* made the run from Houston to Seabrook twice daily.

Disaster struck on September 10, 1900, when a fierce hurricane came up the coast through Galveston. The water rose quickly, causing many residents to scramble for high ground. The train was able to rescue a number of residents, including Erath Repsdorph, of whom Repsdorph Road is named after today. Many prominent local residents stayed and met their fate in the storm, including members of the Rice, Pfluger, Kellerman, and Nicholson families. This devastating blow to the Seabrook Town Lot and Improvement Company caused Seabrook Syndor to declare bankruptcy, resulting in the town site going up on the auction block and being sold in 1901 to Ben Campbell of Houston for $6 an acre.

In 1903, the Seabrook Land Company of Houston filed a revised layout of Seabrook and began selling properties. By 1905, Seabrook had two fine waterfront hotels to accommodate travelers. The Seabrook Hotel was located on Todville Road fronting Galveston Bay, and to the west was the Rouger Hotel, located on the shores of Clear Lake, which later became the location of the Lakewood Yacht Club. Local businesses included the Whiteredge Beer Saloon, Rodick's Restaurant, and Larrabee's Grocery. Ridge Restaurant and Bar, opened on the bay in 1906 by Frank Annello, claims to be the "place that made Seabrook famous." By 1910, the town began to take shape, with a new brick library, Methodist church, Seabrook School, and Dr. Curry's practice.

In 1915, William Burnet Scott, president and founder of Southern Pacific Railroad, built a year-round home for his wife and seven children on Galveston Bay at the "Surf" stop on the newly completed Galveston Bay scenic rail route. The large house, with a basement and first, second, and third floors, was a fine example of mission architecture, with 10-inch-thick concrete walls that withstood many storms and the hurricanes of 1941 and 1961. The children rode the train to Houston for school, and Scott had a private railcar that came up to the house to bring guests for weekend visits and parties. In 1958, the San Jacinto Girl Scout Council bought the mansion and 47 acres of wooded bay front property and named it "Casa Mare." Part of the acreage was sold and developed into the present Seascape subdivision. The home was a colorful part of the Girl Scouts' visits to the bay, creating many scary stories that fueled their imagination of the past. Due to the constant cost of renovation, the house was demolished in 1992.

The automobile began to replace the train, and the first swing bridge was built across Clear Creek, a navigable waterway that wound around the point and then flowed north, forming what was then known as the "good ol' swimming hole" by the locals. Storms and wave actions began to open the cut that later became the channel between Seabrook Point and Kemah, which was permanently dredged eastward in the 1950s, opening the channel directly into Galveston Bay. This began the end of the heyday of Muecke's Place, a mixture of bar, eatery, boat rentals, and gas dock located on the beach that was formed before the cut. Wes Muecke started out in the 1920s when he purchased six blocks from Ben Campbell and built a 100-foot pier to service his fishing and boat repair business. He pioneered the oyster and shrimp business in the area. He tells of his first attempt at catching shrimp with a trawl net, when he had so many shrimp in his net that he could not pull it up. He tried to find a market for his shrimp, but nobody would buy them because, at that time, people did not eat shrimp, they only used them for bait. He had to sell them for 50¢ a bushel, with 60 pounds to a bushel, making it less than a penny a pound. Then he set out lines for catching crabs, which brought a cent each, and trout and flounder at a nickel a pound. When asked what business was like during the Depression, he said, "I made more money during the Depression than I did at any time of my life. People wouldn't have money to pay their bills, but they always had money for fishing."

Life in Seabrook in the 1930s and 1940s was full of community spirit, as many went through the hard times of the Great Depression together. The Bennett sisters—Genevieve, twins Dorothy and Doris, and Ruth Helen—relate what it was like growing up in Seabrook: "After-schooltime was spent helping stock shelves or measure out sugar and flour in the family grocery store located in the middle of town on what is currently known as Second Street. The most exciting time in the summertime was at 9 a.m. when the train arrived and Mrs. Kellett would wheel the mailbags in her cart to the post office." According to Ruth, "Lucille Brummerhop was the postmaster and the kids would go to the window where she would have to figure out whose kids they were so she could hand them the mail." When the telephone arrived, Marian Harral Kidd remembers being used to go and tell different people that they had a phone call. The spirit and uniqueness of this bay front community continues in the lives of many who spent their childhoods growing up in the area. Like Marian, they may go away to college, but the draw of the sea is always there. She returned to raise her family and, along with her brother Rick, preserve the Seabrook of old, with its small-town cottages and stores. In the 1990s, when asked about the charm of what is now called Old Seabrook, she said, "It's the inconsistencies and nonconformity of the area that makes it unique, not that it's old or new."

In Seabrook, variety and character applied to people as well as places. Joe Hester, who was six years old in 1925 when his father opened Hester's Nursery, related in 1990 the cosmopolitan history of society in Seabrook. He said, "We had ranchers and fishermen. Then we had rich oil men from Houston and people who worked in the industry. It has always been a mixed society—and still is." Seabrook is a unique blend of pioneers in a diverse geographical location. From the Native Americans plowing the bay for oysters, pirates seeking refuge in its hidden coves, settlers planting fields for harvesting, fishermen making seafood a business, and boaters calling Seabrook home to oil and space travel, now sought out in our own backyard.

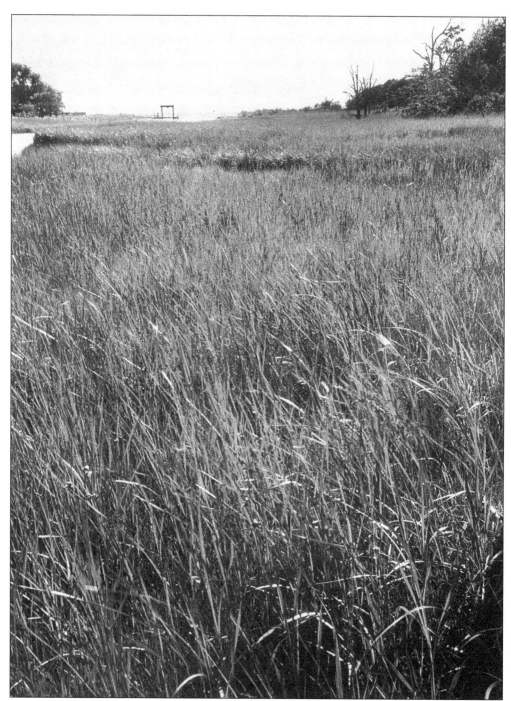

The beauty of the lush green coastline of Galveston Bay has been home to civilizations for centuries. The land that is currently known as Seabrook, Texas, was first the home of the Attakapas, Karankawas, and Cohuiltecan Indian tribes. Sandbars and shell reefs extended far out into Galveston Bay. This photograph is from Pine Gulley Park, where the wetland meets the sea much like it did centuries earlier. The park features a historical site with shell middens, signifying Native American campsites.

One

Morris Cove

Becomes Seabrook

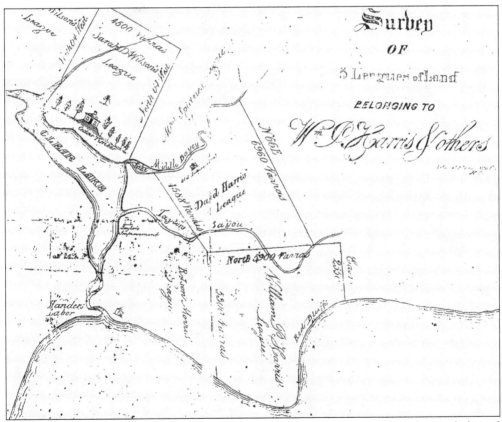

The David Harris survey shows the boundaries of the Spanish land grants that include and surround Seabrook in the early 1800s. David Harris was the brother to John Richardson Harris and William P. Harris, for whom Harris County is named. On November 14, 1842, the Mexican government granted Ritson Morris one league of land at the site that eventually became Seabrook. He named his plantation Elmwood, and it was located in Morris Cove. (Courtesy EML.)

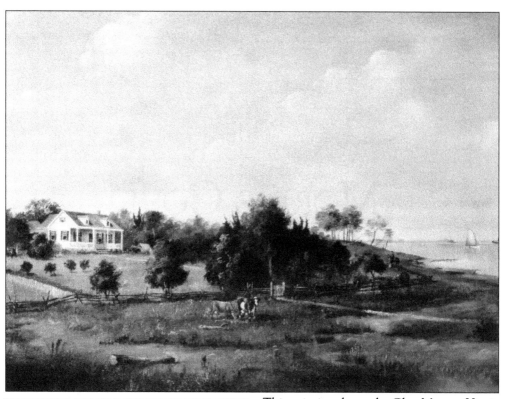

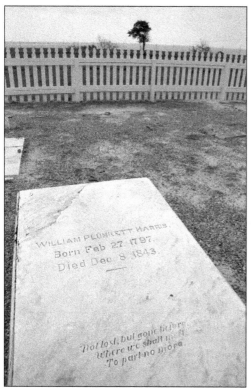

This painting shows the Glen Morgan Harris home as it looked in 1876 when it was built on Red Bluff, a high point on Galveston Bay between Morgan's Point and Morris Cove. This location was named Red Bluff by the Native Americans because of the exposed red clay. Glen Morgan was the son of William P. Harris, and his uncle was John R. Harris, who established Harrisburg. It predated the present town of Houston and was located where the ship channel industry is today. He is buried along with his father and family members on the property. The gravestone in the photograph at left is for William P. Harris, one of the brothers for whom Harris County is named. This is one of the oldest grave sites in the Seabrook area, and the home remains a private residence. A historical marker was erected in the El Jardin subdivision to commemorate the site. (Above, courtesy EML.)

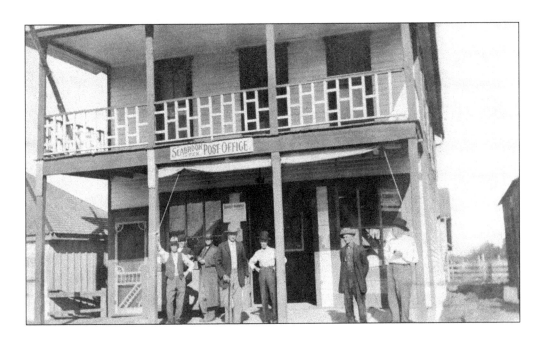

In 1879, the Palmss brothers came to Clear Lake from New Orleans and built the first store in Morris Cove on Clear Lake Road. They settled in the area because they felt Clear Lake, and not Galveston, would be the future port. The two-story building at left in the photograph below is the Palms Brothers store and post office. They also rented transportation to those who would disembark at the Seabrook train station and travel to the bay side resort establishments. Laura Palms grew up in a large two-story Victorian-style house that her father built near the railroad tracks behind the store. She lived there until her death. A fire destroyed the home in the 1980s. Laura's mother was a schoolteacher who came to Seabrook in 1898. Miss Laura was one of the last secretaries of the original Seabrook library that was built in 1911. (Both, courtesy Alecya Gallaway.)

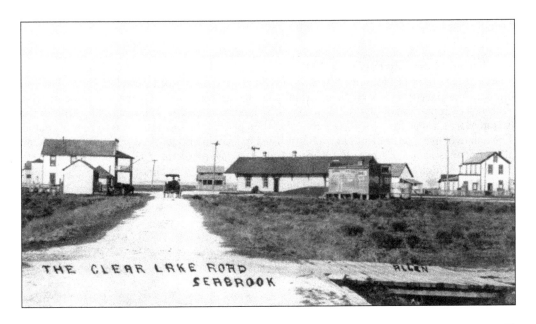

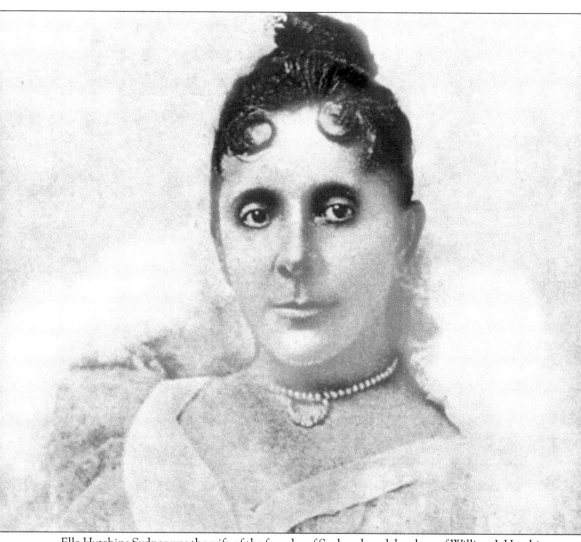

Ella Hutchins Sydnor was the wife of the founder of Seabrook and daughter of William J. Hutchins, a pioneer merchant of Houston. She was a well-known member of Houston society. After an unhappy marriage to Frank Nichols, formally known as Lord Stewart of England, she married Seabrook Sydnor. In May 1895, John Seabrook Sydnor of Galveston purchased 263.3 acres in the Ritson Morris league for his son, Seabrook. He then platted the town that was to bear his name. The names of many prominent Houstonians listed in the Blue Book, along with the Sydnors, are also evident as names of streets in Old Seabrook. Ella died on October 11, 1913, at age 65. Both Ella and Seabrook Sydnor lie in beautiful Glenwood Cemetery in Houston, a resting place for many famous people, including Howard Hughes and Anson Jones. (Courtesy EML.)

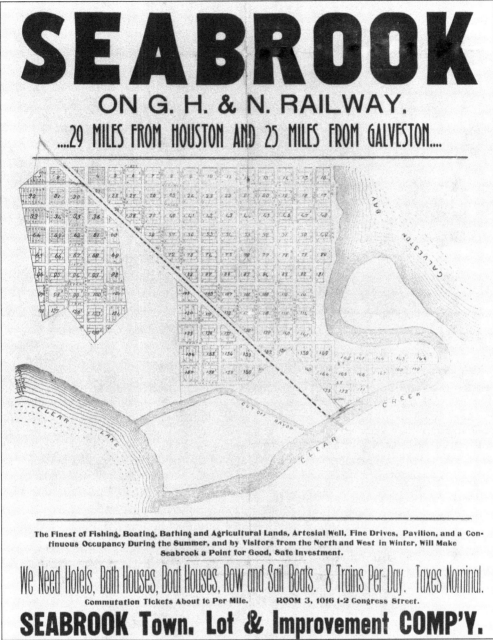

SEABROOK

ON G. H. & N. RAILWAY.

...29 MILES FROM HOUSTON AND 25 MILES FROM GALVESTON....

The Finest of Fishing, Boating, Bathing and Agricultural Lands, Artesial Well, Fine Drives, Pavilion, and a Continuous Occupancy During the Summer, and by Visitors from the North and West in Winter, Will Make Seabrook a Point for Good, Safe Investment.

We Need Hotels, Bath Houses, Boat Houses, Row and Sail Boats. 8 Trains Per Day. Taxes Nominal.

Commutation Tickets About 1c Per Mile. ROOM 3, 1016 1-2 Congress Street.

SEABROOK Town. Lot & Improvement COMP'Y.

The plat for the town site of Seabrook was filed on June 12, 1896, and in the same year a post office was established in the Palms Brothers mercantile store, with Ed Palms as the first postmaster. Seabrook's namesake, Seabrook Sydnor, along with E. N. Nicholson and E. S. Nicholson, platted the tract advertised in the poster for the Seabrook Town Lot and Improvement Company. The layout of the coastline at the time shows the S curve formed by Clear Creek before it reached Clear Lake from Galveston Bay. The penciled triangle at the top indicates the property owned by the Palms family and where Clear Lake Road began. The lots north of Kittrell (Second) Street and east of Bryan Street have subsided and now form what is known as the Back Bay. Hutchins was renamed Todville Road, and most of Bath Avenue has subsided under the bay. (Courtesy Sue Harral.)

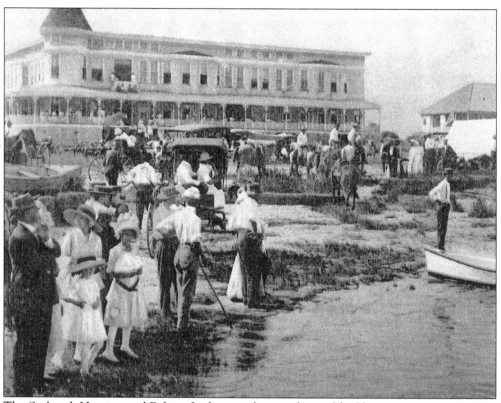

The Seabrook Hunting and Fishing Lodge was the spot for wealthy Houstonians to congregate in the early 1900s. Located near Todville Road on Tenth Street, it boasted a livery stable on ground level, dining rooms on the second floor, and sleeping rooms on the third floor. The large structure of the lodge dominated the waterfront and served as a beacon for boaters in the bay. In 1908, it served as the headquarters for the 1908 annual regatta of the Houston Yacht Club. The 1915 hurricane knocked it down, and it was never rebuilt. (Courtesy Alecya Gallaway.)

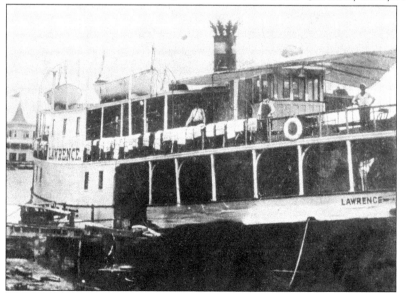

The waterfront of Seabrook in the 1800s was home to wealthy Houstonians who spent their summers by the water. To enjoy cruising on the bay, Seabrook offered a paddle wheel boat, as shown in the photograph, and a small harbor for sailboats. (Courtesy EML.)

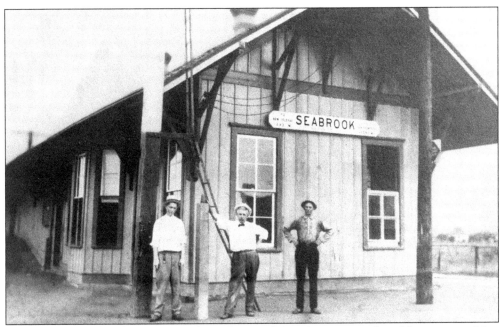

The Seabrook Railroad Station was a busy place, with people coming in from Houston or waiting for goods and mail. A sign on the building advised passengers that it was 393 miles to New Orleans and 1,398 miles to San Francisco. Local residents would regularly use the train to go to Houston for school or work, and Houstonians used it to come to Seabrook for leisure activities, such as boating and fishing. (Courtesy EML.)

This a rendering of Seabrook and Kemah, showing the town lot layout and the Southern Pacific Railroad that ran along the bay side near the summer home properties, connecting the area with Houston. The S curve of the channel shows the waterway around Goat Island as it leads into Galveston Bay. Original channel markers leading out into the bay were located where the end of the S flows into the bay. (Courtesy EML.)

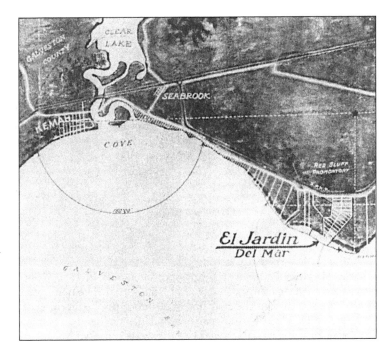

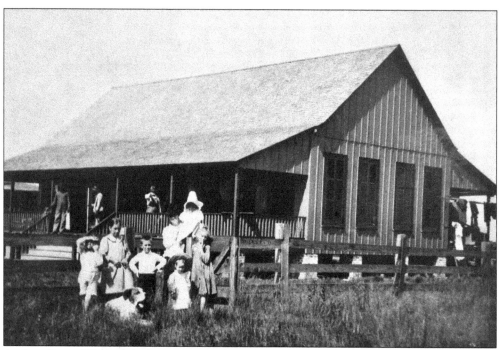

Andrew Dow of Houston built this summer home on Galveston Bay in 1890 (2710 Todville Road). The children, the help, and the dog are his. It was common for wealthy families to move to the bay for the summer. (Courtesy EML.)

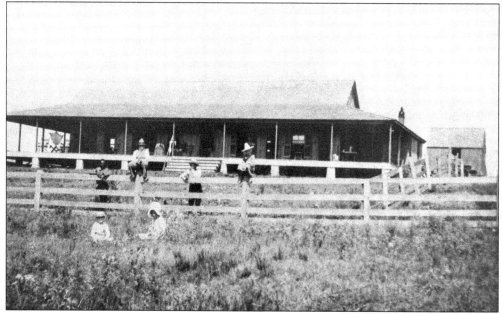

Charles H. Milby built this bay home for his family in 1890 (2614 Todville Road). His home survived the 1900 storm and Hurricane Carla in 1961. The home was overcome by the Hurricane Ike storm surge that hit the coastline of Seabrook on the morning of September 13, 2008. Milby and Andrew Dow were business partners and lifelong friends. Their business partnerships included car dealerships and a coal mine in Oklahoma. (Courtesy EML.)

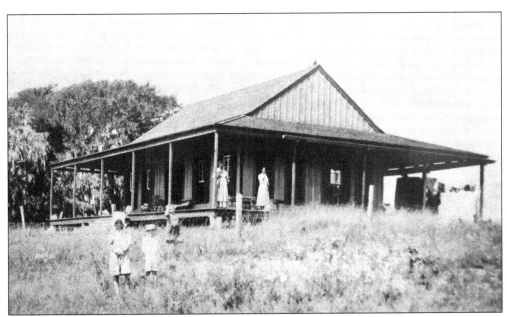

In 1889, this home was the first to be built on what is currently known as Todville Road for Capt. John Grant Tod. Oceola Morris of Morristown became the wife of Tod. Their daughter married Charles H. Milby, a well-known businessman for whom Milby High School in Houston was named. (Courtesy EML.)

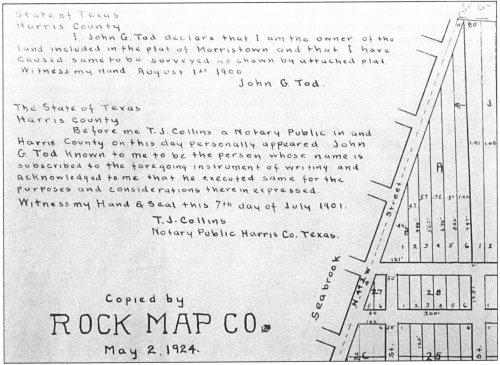

A survey document signed in 1901 by John G. Tod acknowledged his ownership of lots in the plat of Morristown. The street called Todville Road in Seabrook was named after the Tod family. (Courtesy EML.)

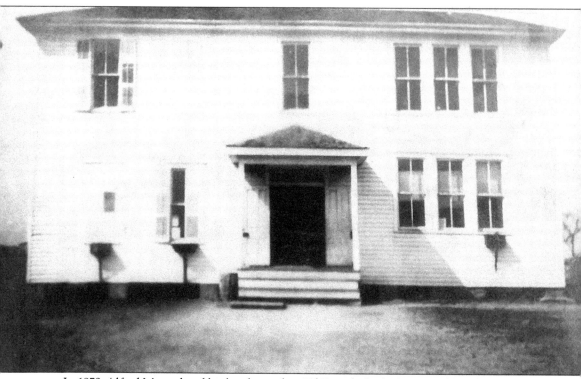

In 1879, Alfred Menard and his brother-in-law, Ed Brantly, built the area's first schoolhouse near Taylor's Bayou. It was attended by 15 students who were 7 to 14 years old. The school also served as a church on Sundays, and Rev. Peter Nicholson eventually bought some land from the Morris heirs and built a home a quarter of a mile from the railroad depot. Seabrook's second school was built on Hardesty Street, one block from Second Street, as shown in the photograph. The school was ready to open in 1898, one year before the big freeze and two years before the storm of 1900. It was commonly called Seabrook Grammar School but was officially part of the Harris County Common School District No. 13. Grades 1 and 2 were on the first floor, and grades 3–7 were on the second floor. Students in grades 8–11 attended Webster High School. Electricity arrived in Seabrook in 1927, and in 1928, George Hamman donated the money to have lights installed in the auditorium. This school remained open until 1930, when the new school opened. (Courtesy EML.)

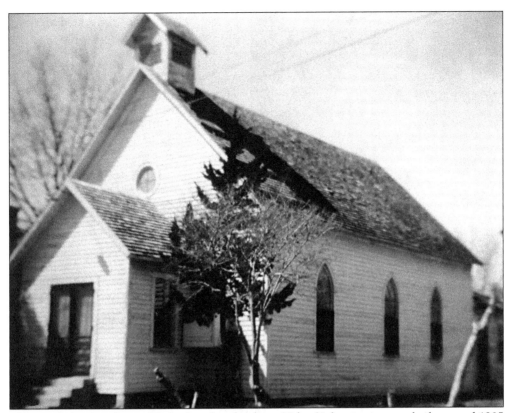

The simple but handsome Methodist church, about 30 by 60 feet in size, was built around 1905 on Hall Street. The first service was conducted by Rev. P. E. Nicholson. Sunday school classes for young people were held in the sanctuary. Bible study for adults took place in the rooms above Chapman's Dry Goods Store on Second Street. (Courtesy EML.)

Winder Bracewell was a Methodist minister who moved to Seabrook in 1918. He was one of the early preachers at Seabrook's Methodist church. He is standing in the middle of one of the many farms then located in the community. (Courtesy EML.)

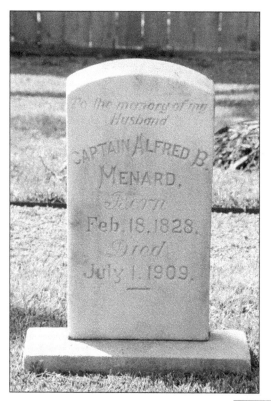

A young Canadian named Alfred Menard, the brother of Galveston's founder Michel Menard, married Ritson Morris's daughter, Virginia, in 1854. Alfred and Virginia built a large home on 100 acres given to them by Morris, where they lived until their deaths. Both are buried in Seabrook in the Menard cemetery, also known as the Morris cemetery.

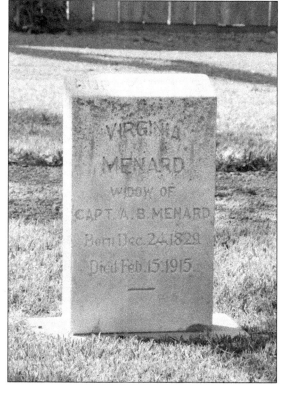

Virginia Morris Menard, the daughter of Ritson Morris, was born in Nacogdoches, Texas, and moved to the area in 1830 at the age of six months. On November 14, 1842, the Mexican government granted Ritson Morris one league of land at the site that would become Seabrook. His plantation, Elmwood, at Morris Cove between Edwards Point and Red Bluff, gave rise to a small town also known as Morris Cove.

The Dobie Family Cemetery was sold to A. B. Menard, and later in the same year, he sold it to Auguste Seureau. It remained in the family and was given in 1907 to Suzanne Seureau, who married James Madison Kellett. In 1912, the site became the Seabrook Cemetery on Pine Gully Road, just off Todville Road. Established in 1855, it bears an official marker as a Historic Texas Cemetery.

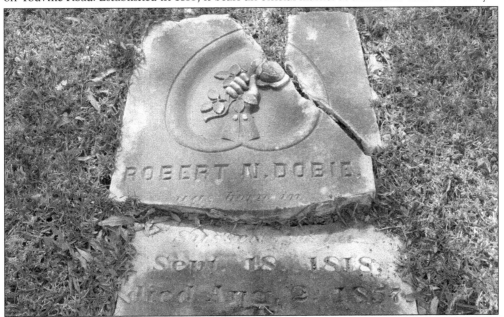

In May 1850, Ritson Morris's daughter Mary Jane married Sterling Neblett Dobie. Morris sold a parcel of land to his daughter in August 1851 that was called the Dobie Family Cemetery. Headstones for Mary Jane's son, James Robert Dobie, who died 1855, and relative Robert Neville Dobie, who died 1857, as shown in this photograph, are the oldest grave sites in the cemetery. Robert was the grandfather of famous folklorist J. Frank Dobie.

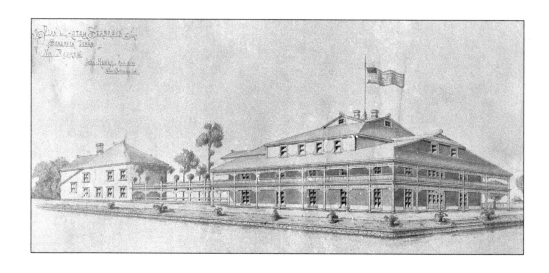

In the late 1800s a New Orleans couple named Rouger saw an opportunity in Seabrook for a hotel, as land was advertised for development in the area, as shown below. Their purchase included the land where the Lakewood Yacht Club's clubhouse is currently located. They built an elegant structure known as the Rouger Hotel, catering to vacationers from Dallas and Houston. Due to a recession, the hotel closed in 1905. For brief period the hotel was known as the Seabrook School for Boys. It was bought and sold and eventually fell into the hands of the local Brown and Graves families, who dismantled the wooden structure and used the lumber in building many of the homes in the Old Seabrook District. (Both, courtesy Alecya Gallaway.)

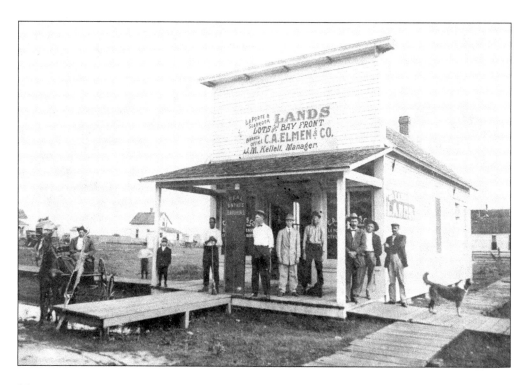

Two

THE EARLY YEARS

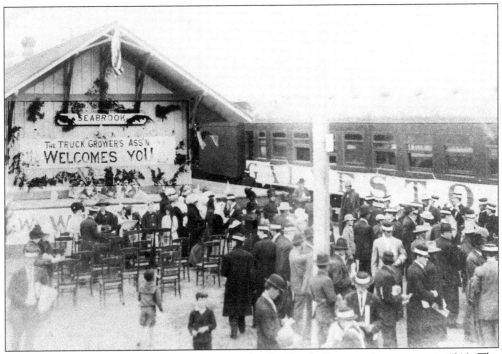

The Seabrook train depot hosted a reception for the Truck Growers Association in 1910. The members were on their way to a convention in Galveston. (Courtesy EML.)

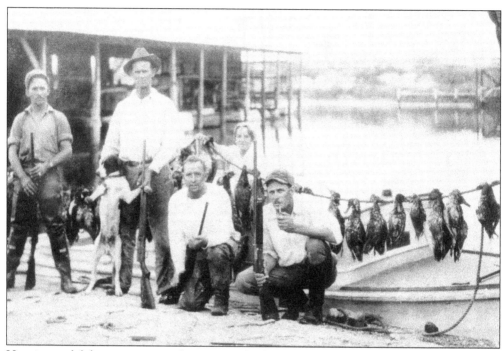

Hunting and fishing were part of many people's lives in the early 1900s. Duck hunters could collect a good bag on Galveston Bay and bring their game home by boat to a Seabrook dock. (Courtesy EML.)

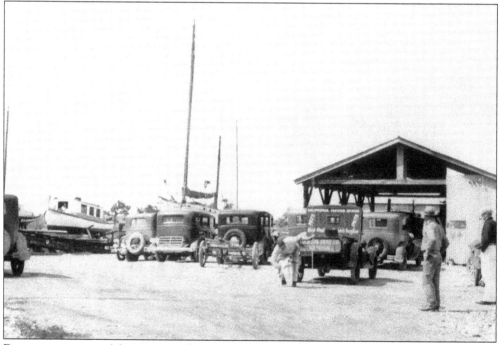

Due to easy access of the water, in the 1920s Seabrook was bustling with activity that involved boats. The city had both working and recreational docks. Today local marinas are part of the third largest boating center in the United States. (Courtesy EML.)

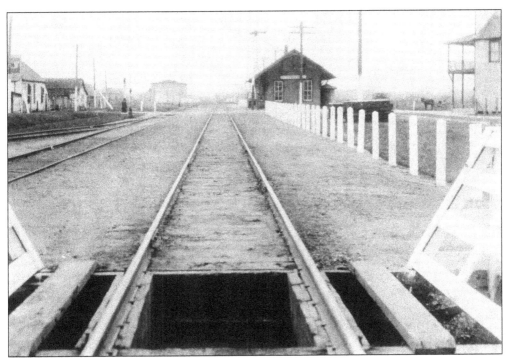

Trains played a big part in Seabrook's history, bringing settlers and tourists alike to the area. In 1886, the construction of the railway gave way to the suburban commuter train, which ran from Houston to Galveston. Early on, mail was thrown off the train and carried to the post office. The original Southern Pacific train depot, located just north of the current intersection of NASA Parkway and Highway 146 on the west side, is shown in the above photograph. The photograph below is from the 1920s, showing Gus Strasding (left) and Paul Gale, father to the boatbuilder "Cooter" Gale. He and his son built around 140 boats from 1945 to 1995 at their shop in Seabrook. (Above, courtesy EML; below, courtesy Leslie Gale.)

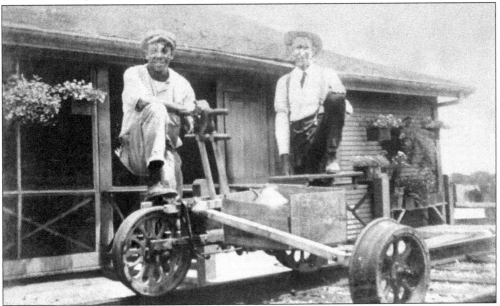

The Ballentine family were early residents of Seabrook. Pictured are, from left to right, (seated) Melissa Aldine and John Ballentine; (standing) A. L., Vetta, and J. A. Ballentine. J. A. Ballentine and Harmon Platzer helped build the first ferry connecting Seabrook to Kemah. Vetta Ballentine twice served as postmistress: July 27, 1918–October 3, 1919, and August 6, 1928–January 26, 1929. (Courtesy EML.)

This home was on the Bracewell family poultry farm that was located on Todville Road in the 1920s and 1930s. Their daughter, Rena Bracewell, grew up on this farm. She was a student at the first school in Seabrook, located on Hardesty Street, and then she moved to the new school that opened in September 1930 on First Street between Cook and Anders Streets. When Rena was 18, her family sold the property and moved away. Five years later, Rena bought back her family home but did not move back to Seabrook until 1961, after teaching school for 21 years. (Courtesy EML.)

In 1900, D. W. Curry bought 10 acres on Highway 146, then a gravel road. In 1902, he built this home for his wife, Etta Wiltsie Curry, Seabrook's first schoolteacher. The property was a strawberry farm until shortly after World War II. In the 1940s, a large dairy farm and a pig farm were also part of the landscape along Highway 146. (Courtesy Larry R. Roberts.)

In this 1916 photograph are Winnie Chapman (left), of Chapman's Dry Goods Store on Second Street, and Lucy Curry, the daughter of Seabrook's first schoolteacher, Etta Wiltsie. (Courtesy Larry R. Roberts.)

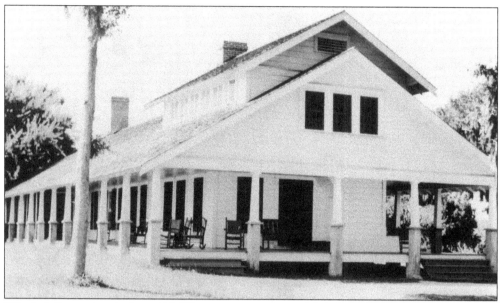

"The Lake" was what the beautiful 250-acre summer estate of E. A. Peden on Clear Lake and Taylor Bayou was called by those who visited for the purpose of being entertained with many tales of buried treasure from the days of Jean Lafitte. The *Houston Post Dispatch* in 1926 observed: "No other single homestead along the entire Gulf Coast, probably, has been invested with so many different stories of hidden treasure and so many different romantic charms as this one—the oldest and, pronounced by many visitors, the most charming place on all the Texas seacoast." As noted in the 1925 survey, the property extended from Kirby Road on the west to Taylor Bayou on the east. (Courtesy EML.)

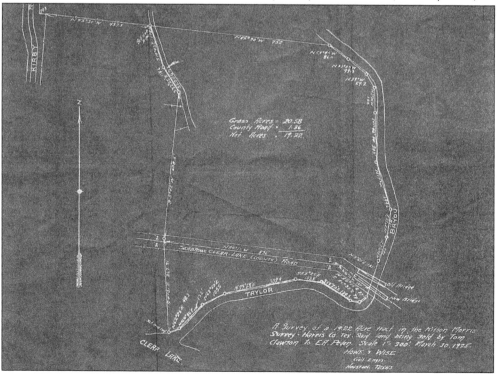

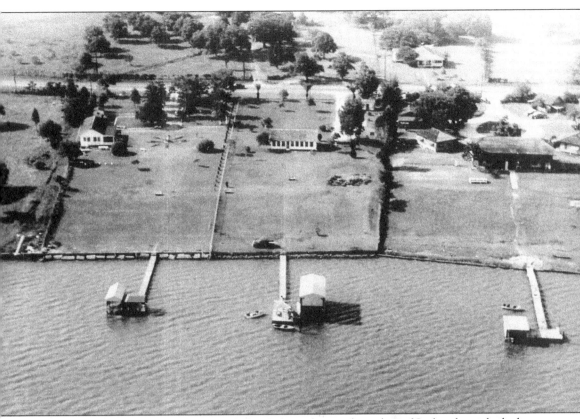

This photograph shows the north shore of Clear Lake at the west boundary of Seabrook as it looked in 1953. The property on the right was part of the large landholding of Peden Iron and Steel of Houston. Also known as the E. A. Peden estate, it included all the land north of FM 528, later renamed NASA Road 1, to Taylor Lake and Taylor Bayou to the west. The estate was a popular summer retreat for Houstonians, where hunting for legendary pirate treasure became part of the entertainment. At the time, local residents remember swimming in Clear Lake, which was described as being a shallow 3 feet deep in most spots. In the 1960s, the land began to subside, sinking 5 feet in 10 years. Before Houston began using surface water in the mid-1970s, its main source was underground supplies pumped from the aquifer below. (Courtesy C. W. Schoellkopf.)

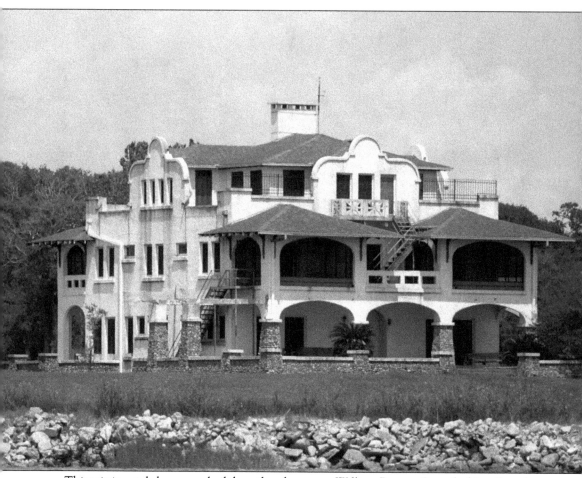

This mission-style home was built by railroad magnate William Burnett Scott for his wife and seven children in 1915. The home was located off Todville Road facing Galveston Bay. Scott believed the bay air helped with his ailment of hay fever. Built to be hurricane proof with 10-inch concrete walls, the Scott mansion withstood many storms, including the hurricanes of 1941 and 1961. The Scott children, Norman, Florence (who later married Hugh Potter of Houston, the developer of River Oaks), Blair, Adelaide, Madge, Austin, and Douglas all rode the train to school in Houston from Surf station, located across from the estate entrance. The commuter train ran along the bay side, with stations at El Jardin, Surf, and Todville before connecting with the *Suburban* in Seabrook. The property was bought in 1959, along with 47 acres of bay front property, by the San Jacinto Girl Scout Council. They named the mansion Casa Mare, and its stories entertained the Girl Scouts until it was demolished in 1992 because maintenance costs were prohibitive.

In 1941, Oscar Key, one of the Key brothers who owned Key Food Market on Second Street in the 1940s and 1950s, was appointed the first fire chief of the Seabrook Volunteer Fire Department. The first fire truck was an old bread delivery truck that was outfitted with a tank and centrifugal pump. The firehouse was located next to the Seabrook Community House on First Street. (Courtesy EML.)

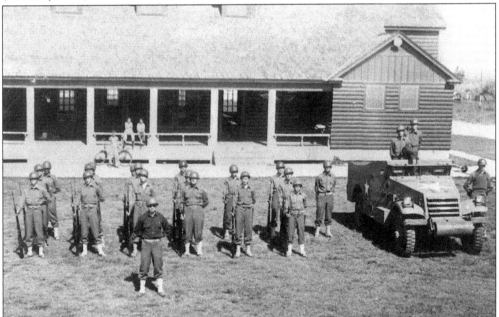

The Seabrook Community House located on First Street was built in 1939 by George Hamman. Hamman came to Houston in 1898, married Mary Josephine Milby in 1906, and became president of Union National Bank in 1943. Mary was the daughter of Maggie Tod Milby and Charles H. Milby; her grandfather was John Grant Tod, who had settled in Texas in 1830 and for whom Todville Road in Seabrook is named. This photograph was taken in 1942 when the National Guard was stationed there. (Courtesy EML.)

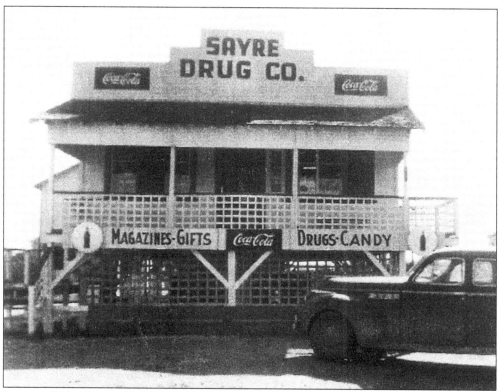

Lewis and Ellie Sayre opened Sayre's Drug Store in 1937 on Todville Road in the Seabrook Flats area—as residents called the low ground near Galveston Bay and Clear Creek. It was the only drugstore in town at the time. Each time there was a storm the building was damaged. Six months before Hurricane Carla hit in 1961, the Sayres moved the whole building up on the hill near the center of town on Second Street. This time there was no damage from the storm. Lewis Sayre was a pharmacist, and after he died in 1944, Ellie Sayre kept the store going without a pharmacist well in to the 1970s and then sold the property to the Kidd family. They restored the structure to its original luster, and it continues to be a hub of retail activity in the Old Seabrook District. (Courtesy EML.)

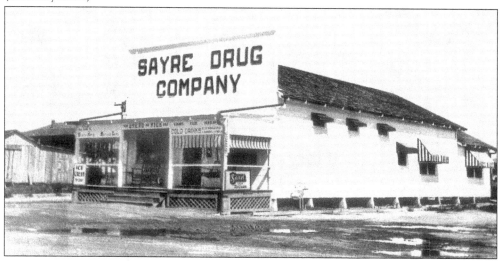

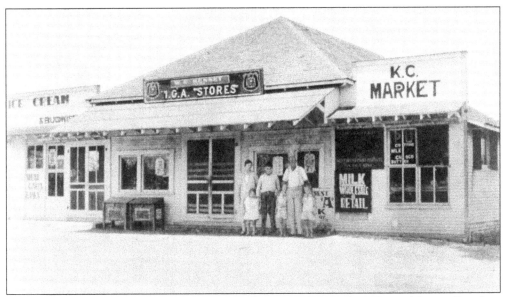

In 1925, Walter Bennett opened a grocery store known as Bennett's on Second Street. Standing in front of the store are, from left to right, Mrs. W. C. Bennett, daughter Ruth Helen, son Edwin, and Walter Bennett with the twins Dorothy and Doris on each side. The Bennetts also had another daughter, Genevieve, who had moved with her parents to Seabrook in 1918 and was already married by the time this photograph of the family was taken. (Courtesy Genevieve Curry Dickerson.)

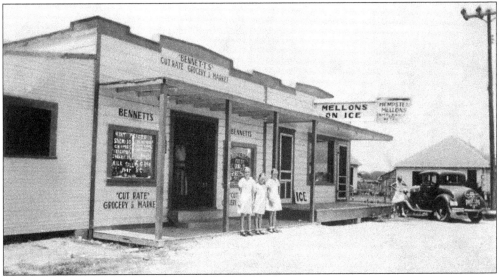

The older Bennett sister, Genevieve, married Adolph Curry, whose grandfather practiced medicine in Seabrook. Genevieve bought the grocery store, Bennett's, from her mother, Anna, in 1953. She then renamed the store Curry's and moved it to another building on the corner of Cook and Second Streets. Adolph and Genevieve Curry raised their three children in a house next to the store. Pictured are, from left to right, Genevieve's sisters, Ruth Helen and twins Dorothy and Doris. (Courtesy Genevieve Curry Dickerson.)

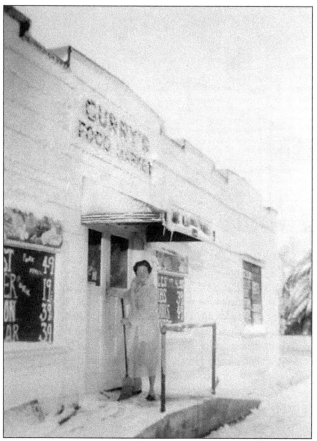

Genevieve Bennett Curry is shown at left sweeping the snow off her porch on one of Seabrook's rare winter snow days. Stores and gas stations in Seabrook prided themselves in keeping the community going in good times and bad by selling most of their goods on credit, trusting that they would be paid later. Curry said in an interview for the *Houston Chronicle* in the 1960s, "It's my charge business that amazes the new people. They've never heard of such a thing as charging groceries." Genevieve (on the right) is shown below inside her store with Della Strasding and Henry Kagawa (in the back of the store). Dell and Henry both worked in the store. (Below, courtesy Genevieve Curry Dickerson.)

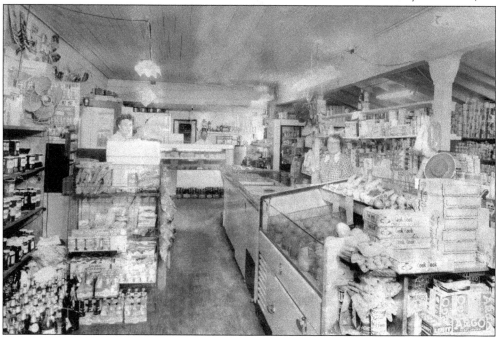

Ellie Sayre of Sayre's Drug Store (right) is shown with Ginny Ratliff, who worked for her at the store's first location on Todville Road near Seabrook Flats. (Courtesy Ratliff family.)

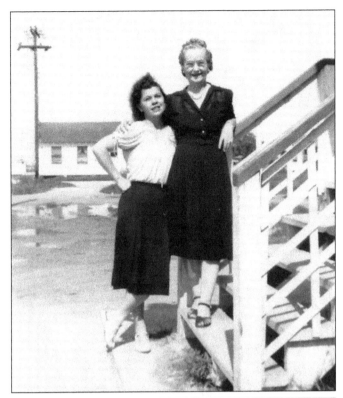

Red-haired Winnie Christy opened her dry goods store, called Chapman's, in 1921 on the corner of Second and Hardesty Streets. When she first started the store, it housed the post office, and she was the assistant postmaster. Her husband, Frank, was a florist, and she started her dry goods business as a separate enterprise. She sold everything from nails to sewing notions. After the store closed in the 1970s, the building remained a vibrant part of the Old Seabrook District until extensive damage from Hurricane Ike in 2008 led to its demolition in 2010. (Courtesy City of Seabrook.)

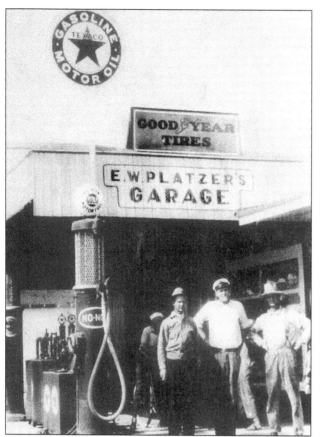

In 1920, E. W. Platzer's Garage became the first full-time service station in Seabrook. It was located at the corner Highway 146 and Second Street. Pictured in the photograph at left are, from left to right, Dan Platzer, Hans Peterson, and E. W. Platzer. A new 1950s Texaco gas station in art deco style was an upgrade from E. W. Platzer's original station on Second Street across from the icehouse, Dickinson Ice and Fuel. At the time, the station was operated by Bert and Ruby Macabee, shown in the photograph below. The station also was owned by several other Seabrook residents, namely E. W. ("Pappy Gene") Platzer, A. R. Stamper, and Shorty Lundy. An old-style gravity pump can be seen against the wall of the building. (Courtesy EML.)

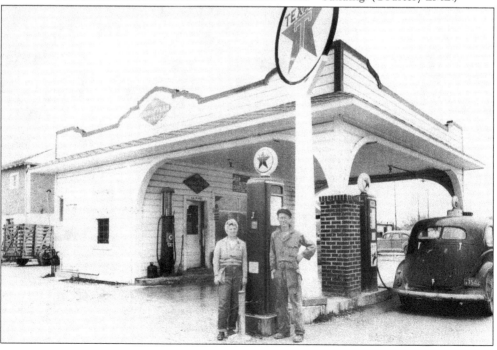

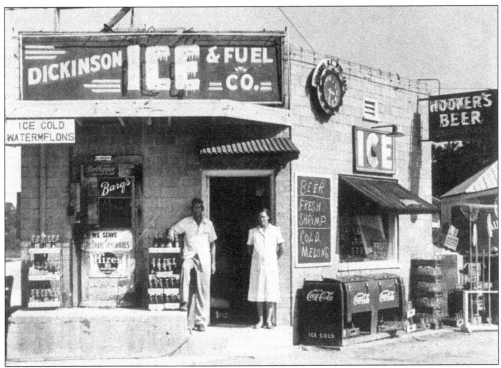

Located at today's busy intersection of Highway 146 and NASA Parkway is a small building constructed in the 1930s as a stop off for travelers to buy ice and fuel between Pasadena and Galveston. It was originally a second location for Dickinson Ice and Fuel out of Dickinson, Texas. It was leased to the Hooker family of Seabrook, and Mr. and Mrs. Hooker are shown above.

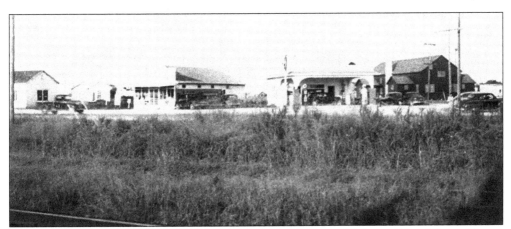

This photograph shows the location of buildings and businesses on Highway 146 and Second Street in the 1940s. The large building on the right is the Seabrook Community House, and Platzer's Garage is shown in the middle of the photograph. (Courtesy City of Seabrook.)

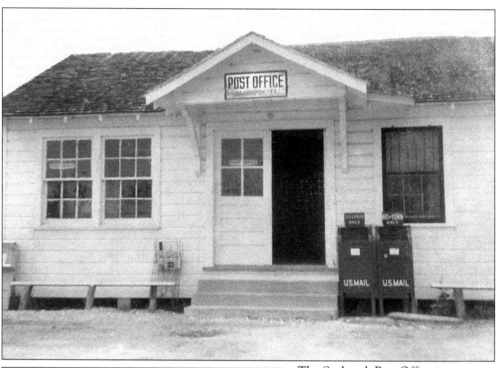

The Seabrook Post Office is shown above at its 1959 location on Second Street. Previously, the Palms Brothers store housed the post office, where the daily mail was rolled in a cart from the train station by the postmaster. This was the first building that served only as the post office. Currently the post office is located across the street from the original building. (Courtesy Mort and Camille Glazes.)

Allen's Community Store
WEBSTER

GOLDEN TRIANGLE LUMBER CO.
South Houston

Barrow Grocery
GENOA

Hall's INSURANCE AGENCY
DICKINSON

The Buckaroo Malt Shop
BACLIFF

Hansen's Feed & Farm Supply
LEAGUE CITY

J.C. Buck's GULF STATION
LEAGUE CITY

KEY BROS. FOOD MARKET
Seabrook

Butler's Hardware Co.
LEAGUE CITY

Kilgore's Grocery Store
LEAGUE CITY

Chapman's GENERAL MERCHANDISE
Seabrook

J. R. KLECKAS
DICKINSON

Citizen's State Bank
DICKINSON

Lane Greer Super Market
SEABROOK

Clear Creek Inn
KEMAH

League City Coffee Shop
LEAGUE CITY

Dad Allen's Place
SEABROOK

Maupin's Grocery
SEABROOK

De George Fishing Camp
SEABROOK

MEADOW BROTHERS, INC.
South Houston

Funston Jewelry
SOUTH HOUSTON

Meadowbrook Lumber Co.
PARK PLACE

Galloway Beauty Shop
WEBSTER

The 1949 yearbook for Webster High School featured advertisements for a number of Seabrook businesses. (Courtesy Ratliff family.)

Gus Meyer worked for Howard Hughes, and he built a home at 2810 Todville Road in the 1920s. He is shown above attending a picnic with his family at Sylvan Beach, hosted by Hughes Tool Company. From left to right are Joan, Gus, Eleanor, Jeanette, and Lillian Meyer. Meyer was also very interested in education and suggested the consolidation of the Seabrook, Kemah, and League City schools into a single district, which today is known as the Clear Creek Independent School District. Early on, the Meyer family was one of only four families who had a telephone, and during emergencies people would come by to use the phone. Meyer's ranch stretched from Red Bluff Road to Sunrise Drive in La Porte. The Todville Road house shown below was the family's main residence, and they also had two houses on the ranch land, one of which was occupied by daughter Eleanor and her husband, Henry Lee Scott, until the 1960s. (Courtesy Eleanor Scott.)

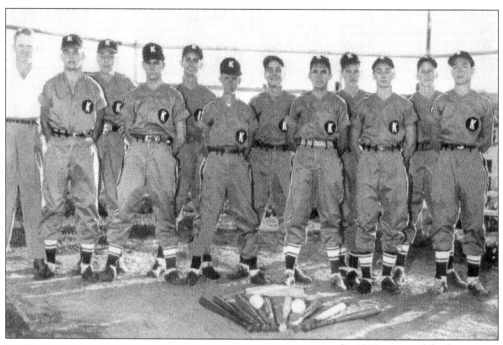

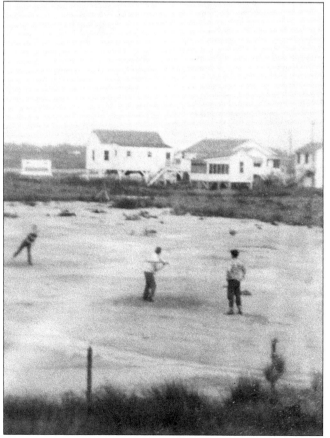

In 1949, most of the boys in town were on Seabrook's baseball team. When teams from surrounding towns came to play, they played at the baseball field that was located near Second Street and Todville Road. In the 1960s, this property subsided underwater. The boys in the photograph are, from left to right, shortstop George Lundy, first baseman Larry Roberts, pitcher Jimmy Brown, catcher Byrd Menard Jr., shortstop James Miller, third baseman Joe Pattillo, second baseman Bart Dickerson, right fielder Bill Chavers, second baseman Jack Quinn, center fielder John Wilkes, and left fielder Loyd Lehew. The coach at far left above was Bill Robinson, who would later become the mayor. The team was sponsored by the Key Brothers Food Market. (Above, courtesy Larry R. Roberts; left, courtesy Ratliff family.)

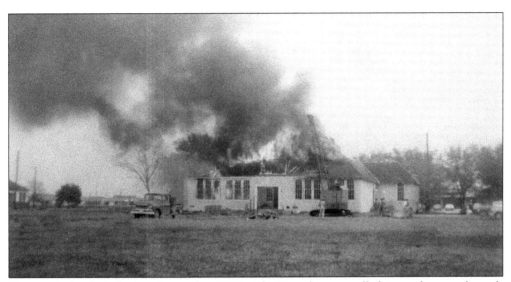

The new school opened in September 1930 with 65 students enrolled in grades one through seven. It was constructed with reinforced concrete for the slab and walls and a slate tile roof for a total cost of around $20,000. Red and black tiles covered the concrete floor, which proved to be a problem, with moisture being absorbed from the ground, causing the concrete to sweat. Unlike the earlier school, teachers and students enjoyed electric lights and two outside restrooms with flushing toilets at this school. Nurseryman Joe Hester planted the stately row of oak trees that still stand on the property. This school was last used for regular classes in 1948. The photograph shows the abandoned school building on fire during demolition. The city hall was then built where the school once stood. The photograph below is of the girls' basketball team in the early 1930s. (Above, courtesy Genevieve Curry Dickerson; below courtesy EML.)

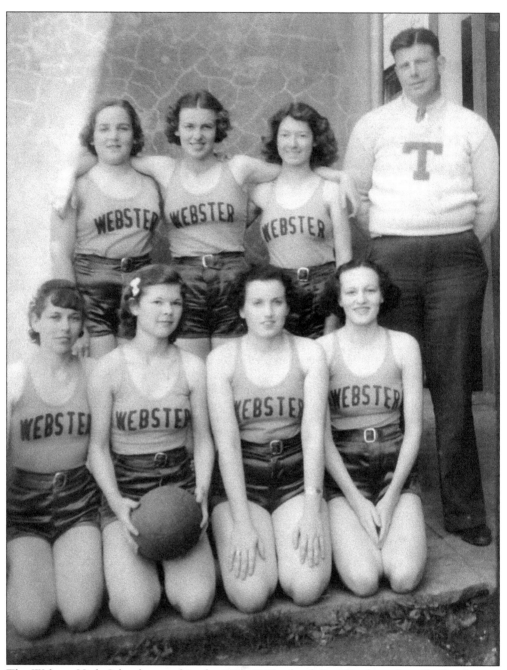

The Webster High School opened in the 1939–1940 school year. Students from Seabrook went to school there after finishing the seventh grade. The photograph is of the girls' basketball team in 1940, with Jack Rhodes as coach. Pictured here are, from left to right, (first row) Henrietta Freund, Charlie Burns, Ona Mae Beeman, and unidentified; (second row) Pokie Platzer (Stamper), Virginia Hubel, Tag Burns, and Jack Rhodes. (Courtesy Pokie Platzer Stamper.)

Kid Day was for seniors graduating from Webster High School in 1940. The photograph at right shows Pokie Platzer sitting on the left. Her father was a boatbuilder in the area. She later married and became Pokie Stamper. She opened P. S. Yachts, a boat brokerage, in Seabrook in 1984. The photograph below is of Junior Wetz (left) and Charlie "Chubby" Burns in 1939. (Both, courtesy Pokie Platzer Stamper.)

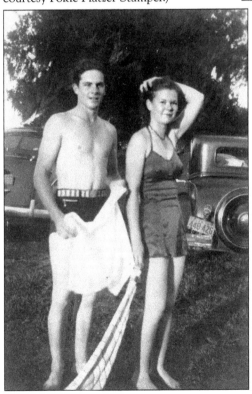

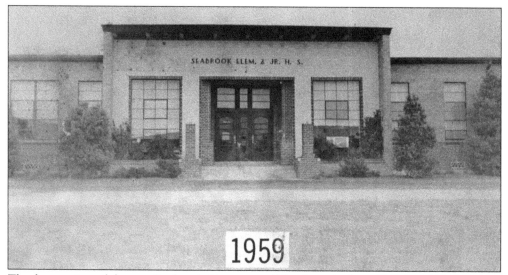

1959

The first section of the new Seabrook Elementary School was built in 1949. In 1945, Seabrook became an independent school district, and James Foster Bay became superintendent. All of the area's school districts consolidated in 1948, forming the present-day Clear Creek Independent School District. With the coming of NASA in the 1960s, the children of astronauts Neil Armstrong—the first man to walk on the moon—Scott Carpenter, Charles Conrad, Frank Borgmen, Don Eisele, Virgil Grissom, and James Lovell were students at Seabrook School. The photograph below was taken during the 1965–1966 school year before the school was renamed Bay Elementary in 1969. (Above, courtesy Pokie Platzer Stamper; below, courtesy Bay Elementary.)

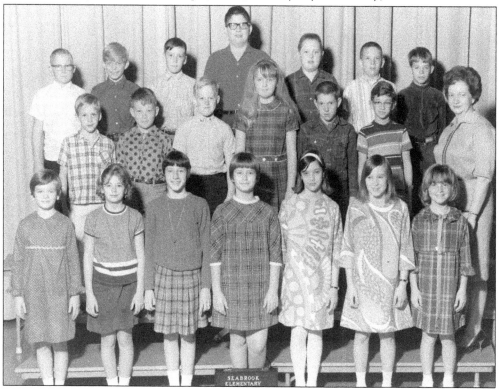

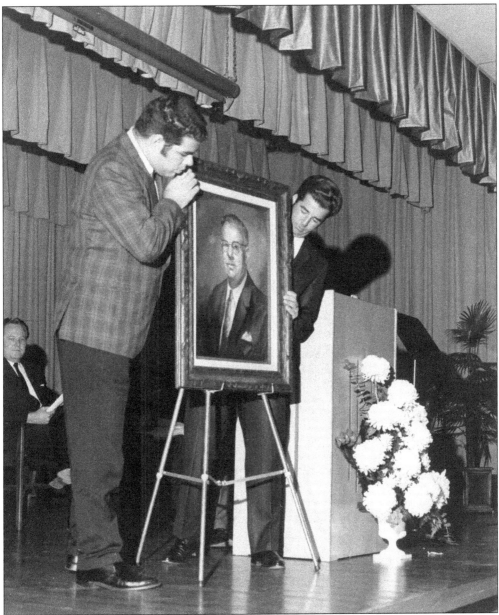

James F. Bay was principal from 1948 until 1965. Bay taught two generations of Seabrook schoolchildren. He died in November 1968 and is buried at the Seabrook Cemetery. When Seabrook Elementary was renamed James F. Bay Elementary in his honor in 1969, this photograph of Bay's two sons looking at their father's portrait was taken at the dedication. (Courtesy Bay Elementary.)

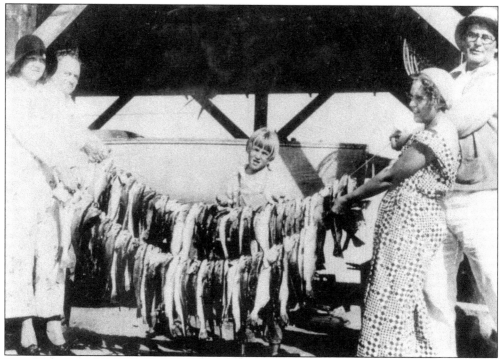

Visitors are showing off their catch of fish from the local waters of Seabrook in the 1930s. In those days, people could rent a skiff from Muecke's or Oddo's and spend the day on the bay catching fish. Speckled trout, flounder, and red fish were among the prized fish to catch. (Courtesy EML.)

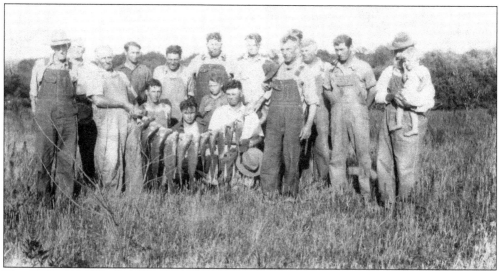

The Curry and Chapman families are showing off their catch of fish from Galveston Bay near Todville Road. It was common to catch large speckled trout and red fish from along the banks of the bay. (Courtesy Larry R. Roberts.)

Three

SEABROOK WATERFRONT

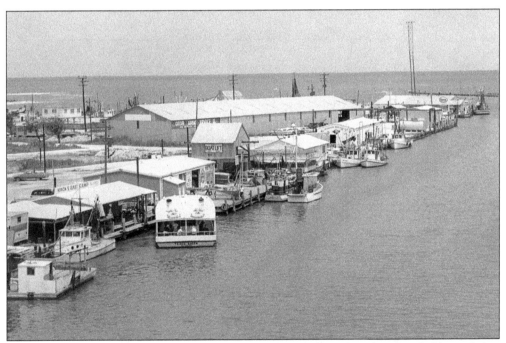

In the 1960s, the commercial waterfront in Seabrook ran along the Clear Creek Channel that was dredged for boats to travel into Galveston Bay. With the growing demand for fresh Gulf seafood, Seabrook became a hot spot for shrimp and oyster fisherman. (Courtesy Betty Campbell and Guy and Kris Brummerhop.)

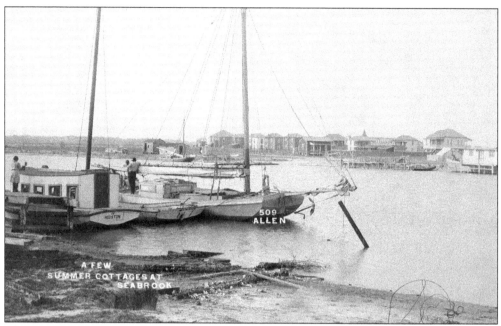

This postcard is a view of the waterfront where the Harris County ferry transported people from the banks of Seabrook to Kemah in 1910. (From Lakewood Yacht Club, courtesy John Cordes, harbor administrator.)

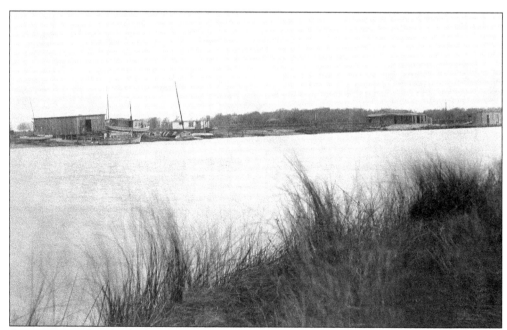

Cottages, as they looked in 1910, hugged the Seabrook waterfront. They were popular residences for summer visitors to the coast. (From Lakewood Yacht Club, courtesy John Cordes, harbor administrator.)

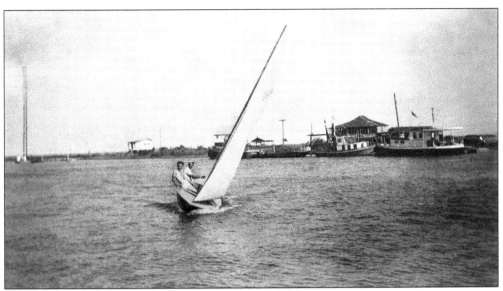

The above photograph was taken in 1948 of Lewis Williams (left) and Jack Barnes (right) sailing on a Snipe, a popular recreational sailboat of the time. Both were early members of the Seabrook Sailing Club and were part of the original group that promoted sailing in the area. The photograph below was taken in 1959 and features two young sailors learning to sail on a Sailfish, which pre-dated the Sunfish. It had a flat top with non-skid paint and a small teak rail on each side. Since the Seabrook Sailing Club was located on Galveston Bay off Todville Road, it offered easy access to the local waters. (Both, courtesy Loretta Muilenburg.)

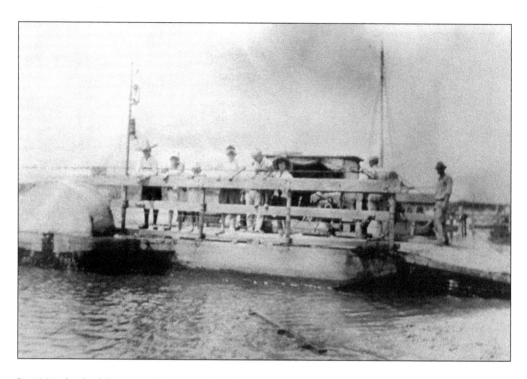

In 1900, shipbuilders J. A. Ballentine Sr. of Seabrook and Harmon Platzer of Kemah built the first ferry, shown in the above photograph, connecting the two communities. It was propelled by a hand-cranked cable system. Beginning in 1901, for 21 years, George Dudley's strong arms pulled the cable that turned the wheels of the ferry. People of all sorts rode the ferry between Seabrook and Kemah in the days up until 1929 when a drawbridge was opened. The first bridge built was a one-arm drawbridge, as shown in the photograph below taken in the mid-1950s. Located next to the bridge was Bub's fishing camp, a popular spot to stock up on live bait before heading out into Galveston Bay for a day of fishing. (Above, courtesy EML; below, courtesy Dr. Ed Staggs.)

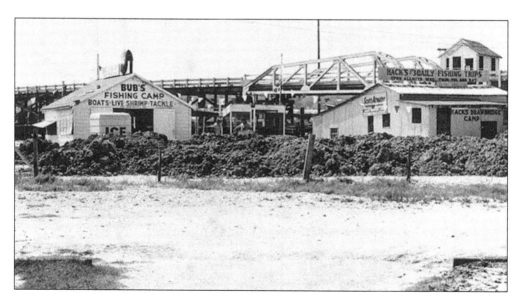

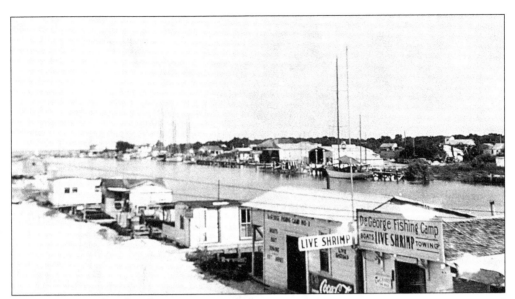

The waterfront of Seabrook in the 1930s is lined with fishing camps where people could stock up on bait and snacks before heading out for the popular Galveston Bay fishing spot. Seabrook was known throughout Texas for abundant speckled trout and flounder,. (Courtesy Alecya Gallaway.)

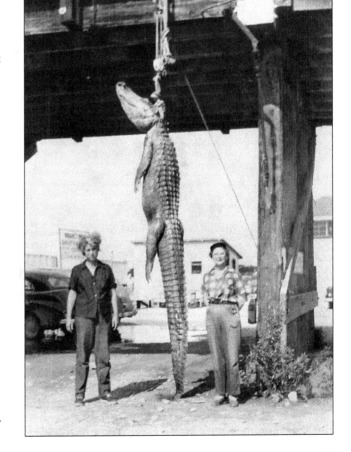

This alligator was caught in Clear Lake in the 1950s. From left to right are local residents Mrs. Smith and Mrs. Hack, owner of Hack's Bait Camp on Clear Creek. The alligator is hanging from the one-arm drawbridge between Seabrook and Kemah. (Courtesy Ratliff family.)

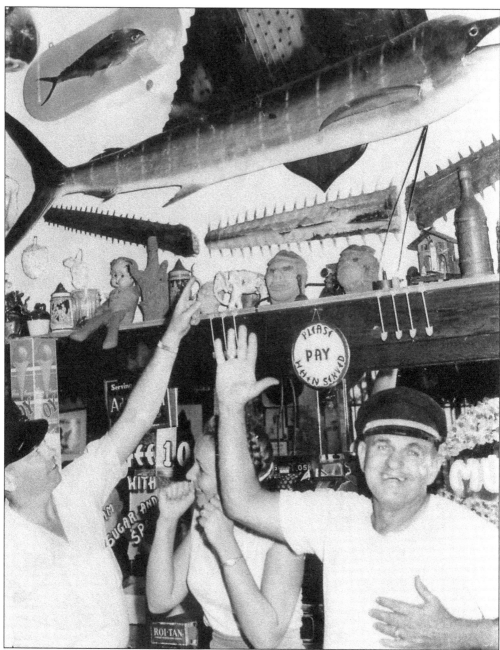

Wes Muecke, owner of the famous Muecke's Place, is shown at right in the photograph above. He came to Seabrook in 1919 with a 16-foot powerboat and 10 skiffs to start his boat rental business. He then bought six lots from old Ben Campbell, who had acquired all of the lots belonging to the Seabrook Town Lot and Improvement Company in an auction. A boat repair yard and a place for people to hang out by the water were later added. By the 1940s, Muecke's was the swinging place to be, with its unique menagerie of decorations inside the restaurant, as shown in this photograph. It was located on Galveston Bay, behind a shell reef called Goat Island that formed a beach along Todville Road. In 1981, the water action from Hurricane Allen pushed the sand and shells from the island into the Clear Creek Channel, causing the island to disappear. (Courtesy EML.)

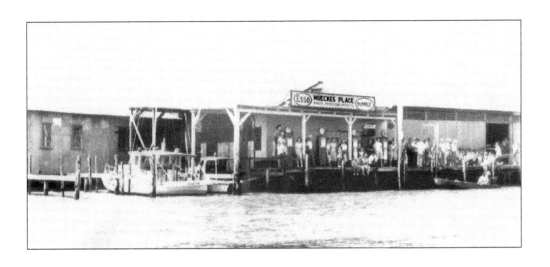

From the 1940s into the 1950s, when these photographs were taken, the Seabrook waterfront along Todville Road had a large beach area with a popular swimming hole, which made Muecke's Place the place to be. A quote from the postcard below states: "'Muecke's Place', in Seabrook, Texas has been a mecca for fishermen and those in a holiday mood since the day it opened in August 1920. Wes Muecke, the host and owner, is a familiar figure to thousands who visit the bar and museum which contains over 1,000 specimens collected over a period of 30 years, and each has its own special story. The free fishing pier and bathing beach, zoo, picnic grounds, the largest dry storage facilities for boats on the Texas coast, the speed boat rides—all these and many more attractions go to make 'Muecke's Place' a MUST, whether for just a 'quickie' or a full vacation." J. B. Light is the man on the boat in the postcard photograph below. (Above, courtesy Ratliff family; below, courtesy Larry R. Roberts.)

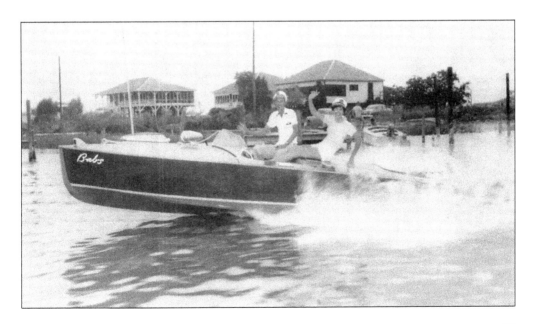

Pokie Platzer (right), her brother, Scatter (left), and her mother, Julia (front), are shown in this photograph with the sailboat that Scatter built along with his father, Harmon Platzer. Pokie grew up in a boatbuilding family and later, in 1984, she opened P. S. Yachts, a boat brokerage in Seabrook. (Courtesy Pokie Platzer Stamper.)

The Ratliff brothers are playing on the equipment used to dredge the channel that, at one time, existed between Goat Island and Seabrook's coastline along Todville Road. (Courtesy Ratliff family.)

Seabrook Flats, the low area where Clear Creek meets Galveston Bay, holds many fond memories for those who grew up in the area. Days were filled with fishing, swimming, and crabbing. Standing in front of their makeshift fort on the flats are, from left to right, brothers Mike and Edward Ratliff and Jesse Henry. (Courtesy Ratliff family.)

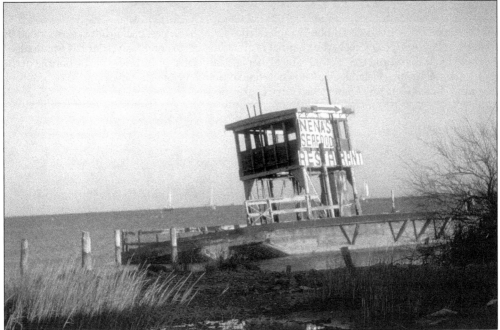

After the ferry was put out of operation, it was laid to rest near Muecke's bar on Todville Road. Each passing storm and hurricane made it sink deeper into the water. To the children who grew up in Seabrook in the 1940s and 1950s, it was a popular deck for getting a suntan or jumping from for a swim in the bay. Remnants of the ferry are shown in this photograph taken in 1978. The old ferry disappeared after Hurricane Alicia in 1983.

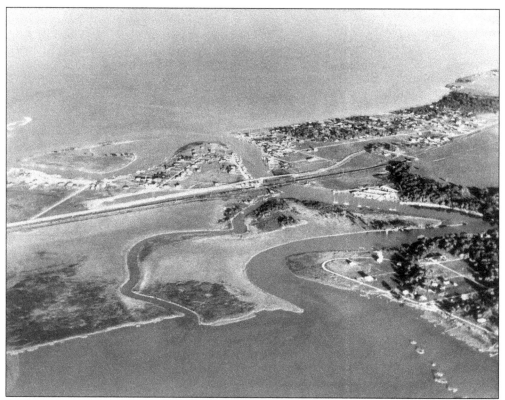

At the time of this 1930s aerial photograph of the "Point," the peninsula that is surrounded by Galveston Bay and Clear Creek, the channel to allow boaters to enter Galveston Bay was dredged between Goat Island and the "Point." The S-shaped island west of the bridge at the bottom of the picture shows Jennings Island, also known as Snake Island, before the development of Seabrook Shipyard there. (Courtesy Genevieve Curry Dickerson.)

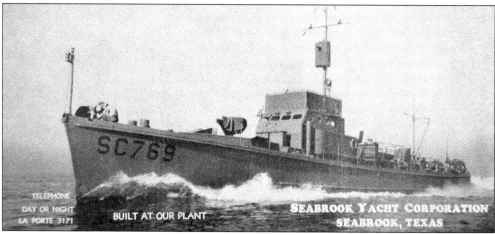

In 1938, Albert and his brother, Ernest Fay, opened the Seabrook Shipyard for building boats. *Subchaser 769* was built at the Seabrook Shipyard for World War II. Before the end of the war, Seabrook Shipyard was to build six subchasers and eight crash boats. Albert Fay commanded a similar boat in the Gulf and Atlantic. He also served on the staff of the Submarine Chaser Training Center in Miami. (Courtesy Seabrook Marine, Inc.)

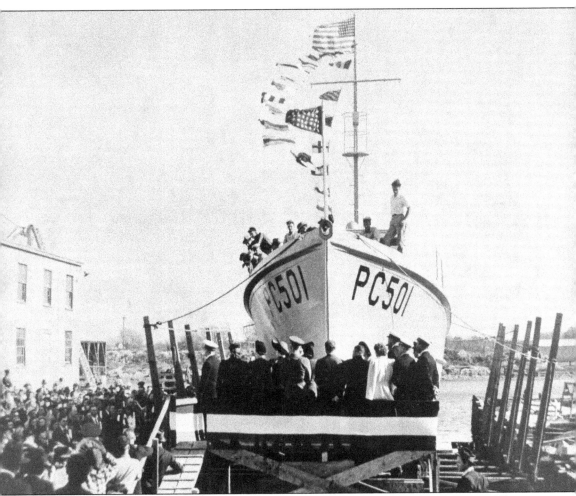

PC 501 was the first patrol cruiser boat completed on the Texas coast since the war began. The *PC 501* sponsor was Homoiselle Fay, Albert Fay's wife. As the LaPorte High School band played the national anthem, Homoiselle christened the boat with a big blow of champagne to its bow on November 1942 at the Seabrook Shipyard. At the christening for the first PC boat, Captain Dupre stressed the importance of this type of vessel. Its primary purpose, he said, "is for the anti-submarine battle and the battle of the Atlantic. It was a battle to get the supplies to our allies now and the battle to save England from strangulation." About a week later, the second patrol cruiser boat was launched. (Courtesy Seabrook Marine, Inc.)

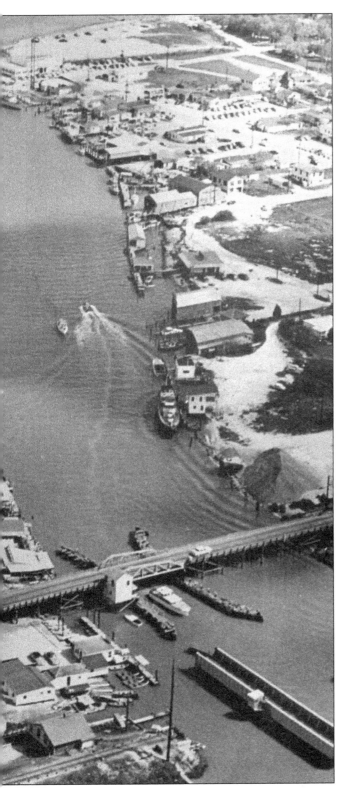

The southernmost promontory along the Seabrook waterfront, known as the "Point," is shown in this aerial photograph taken in the late 1940s. Before the Clear Creek Channel was widened and deepened, boats came in from the bay along a channel that ran between lower Todville Road and Goat Island (an island destined to disappear). In 1938, the Fay brothers purchased the property known as Jennings Island near the mouth of Clear Lake. During World War II, the Fays were awarded contracts to build two submarine chasers. Before the war ended, the Seabrook Shipyard was to build six sub chasers and eight crash boats. Activity at Seabrook Shipyard and the "Point" took off during this period, with Muecke's Place, seafood markets, and the shipyard making the area a busy place all year, especially during the summer months when Houstonians fled the stifling heat of the city for cooler bay breezes at their Seabrook summer homes. In the lower part of this picture is the old one-arm bridge that served the area until the early 1960s. (Courtesy Henry "Kitch" Taub.)

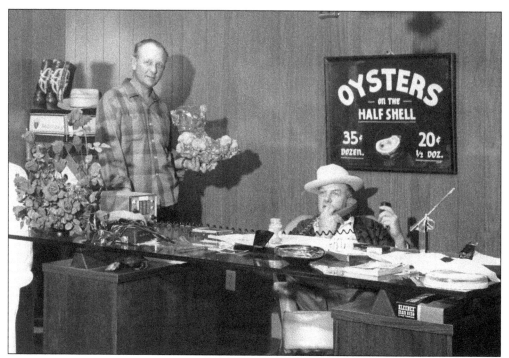

This photograph shows brothers Louis and Kenneth Muecke in Louis's office in 1968. Their father was Louis John Muecke, brother of Wesley Muecke, who owned the famous beachfront bar and restaurant, Muecke's Place, on Todville Road in Seabrook that opened in the 1930s. Hiram Muecke Sr. was also a brother to Louis John Muecke, and he was a boat captain for the wealthy Fondren and Finger families from Houston, who had summer homes in Seabrook. (Courtesy Louis Muecke's daughters.)

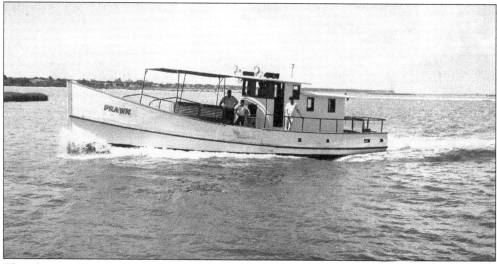

This photograph was taken around 1955 when Louis Muecke was using his boat, the *Prawn*, as a party fishing boat. The *Prawn* was built about 1926 and was used in Louis's seafood business until it burned in the mid-1970s at the Seabrook Shipyard. When it caught fire, it was being repaired in a shed alongside the Fay's racing boat. Louis was heartbroken over the fire and loss of his beloved *Prawn*. (Courtesy Louis Muecke's daughters.)

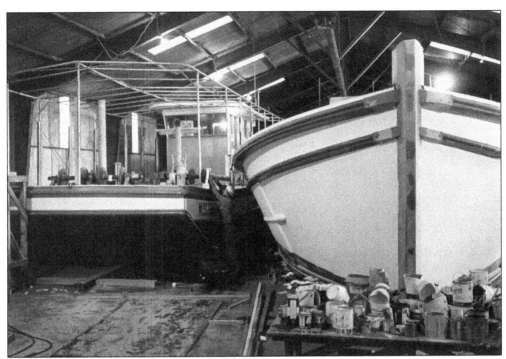

The long tin building shown in the 1966 photograph above of the waterfront was called the George Light Building after its owner. This space was used for building the many fishing boats that lined the channel. This photograph shows two of the oyster boats designed by Louis Muecke under construction. On the left is the *Miss Lynda M.* and on the right is the *Miss Glenda M.* In April 1968, the *Miss Lynda M.* was launched from the George Light Building into the Clear Creek Channel, as shown in the photograph below. Louis Muecke had four daughters: the two boats he had built and designed were named after Lynda and Glenda, and two of his oyster leases were named after Nancy and Patsy. (Both, courtesy Louis Muecke's daughters.)

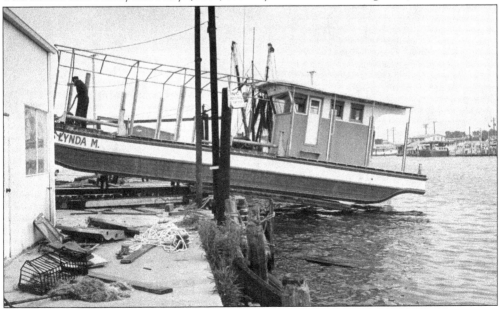

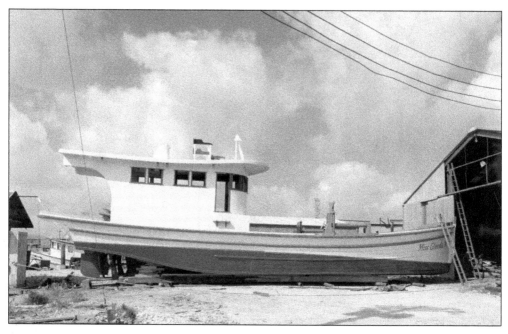

In June 1972, the *Miss Glenda* M. was launched. She was a special boat designed by Louis Muecke that he had built especially for oyster fishing. Her size was larger than most and, therefore, a larger opening had to be cut from the George Light Building to facilitate her launch. She is also shown in operation in Galveston Bay near the oyster leases. After Louis Muecke passed away in 1993, Romeo Bilic of Seabrook bought the *Miss Glenda* M., and she remains in operation out of Texas City, Texas. (Courtesy Louis Muecke's daughters.)

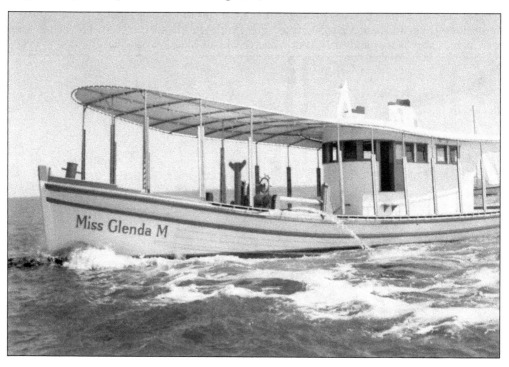

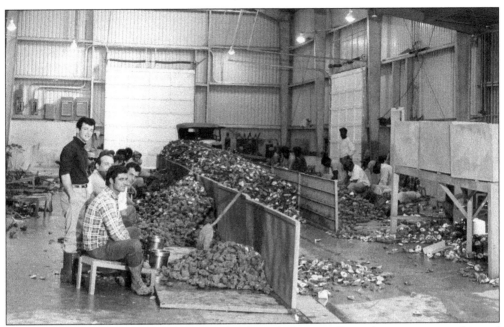

Muecke's Seafood sold only prime cultivated and certified oysters. Since the oysters were cultivated from oyster leases in Galveston Bay, they could offer fresh oysters on a year-round basis, unlike wild oysters that are caught only during winter months. These two photographs show the oysters being shucked, or taken out of the shell, and then washed before they are put in jars for delivery to distributors in Texas, Louisiana, and Mississippi. Muecke's Seafood sold the oysters retail and to seafood restaurants all around the United States. (Courtesy Louis Muecke's daughters.)

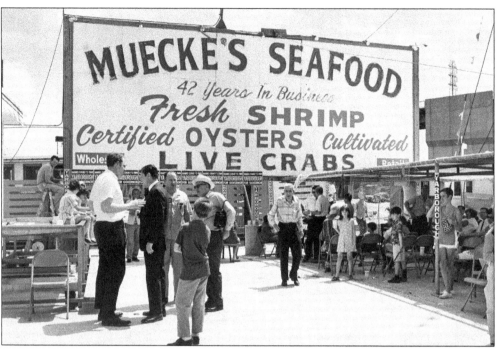

Louis Muecke owned and operated fish markets in Pasadena, then Port Bolivar and Deer Park, Texas, before leasing waterfront property in 1961 from Ben Taub in Seabrook to start his commercial seafood business. In September 1961, Hurricane Carla wiped out his seafood market in Port Bolivar, and his only boat left was the *Prawn*. He and his brother, Kenneth, rode out Hurricane Carla in 1961 aboard the *Prawn*. He was one of the first to obtain an oyster lease from the Texas Parks and Wildlife Department around 1967. These photographs were taken in July 1965 when Louis hosted a campaign fish fry dinner for U.S. senator Don Yarborough. The Mueckes donated all the food and cooked for over 5,000 people. (Courtesy Louis Muecke's daughters.)

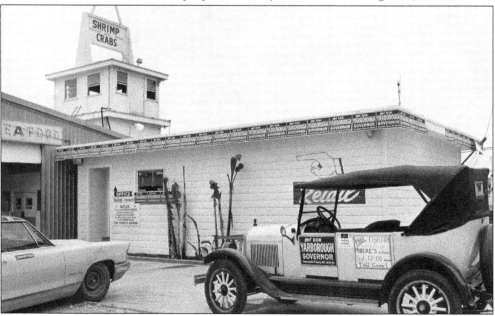

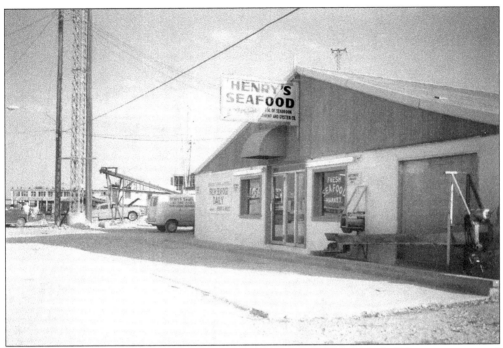

Henry Hults was one of the first to open a store in the 1960s, selling fresh Gulf shrimp, oysters, red snapper, speckled trout, and Texas blue crabs retail to the public on Eleventh Street in Seabrook. (Courtesy Louis Muecke's daughters.)

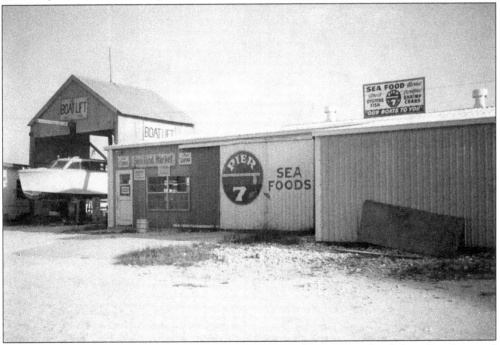

Wesley Buller opened Pier 7 in 1962 on Eleventh Street. The Foreman family later bought it and operated their shrimp and oyster business from this location until 1983, when Hurricane Alicia destroyed the building. (Courtesy Louis Muecke's daughters.)

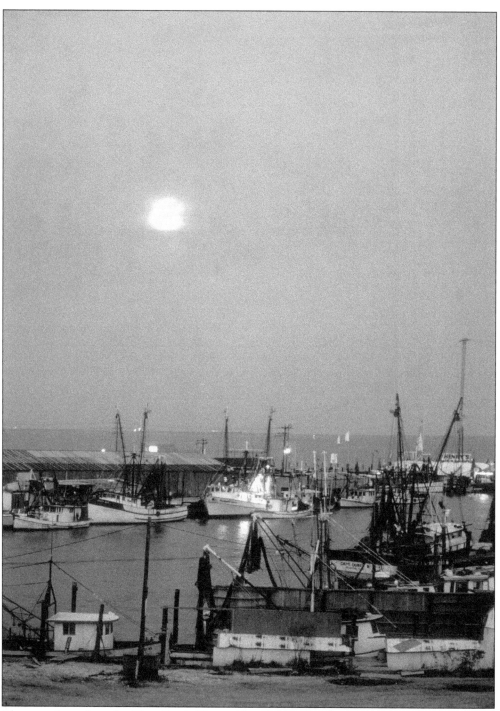

The waterfront along the Clear Creek Channel between Seabrook and Kemah in the 1970s, when this photograph was taken, was lined with commercial fishing boats for catching primarily shrimp and oysters from the bay. Shrimpers, which is what those who caught shrimp were referred to as, were a hardworking group that had to spend many hours taking care of their boats and mending nets. In this photograph, they are shown working late in the evening with moon high above.

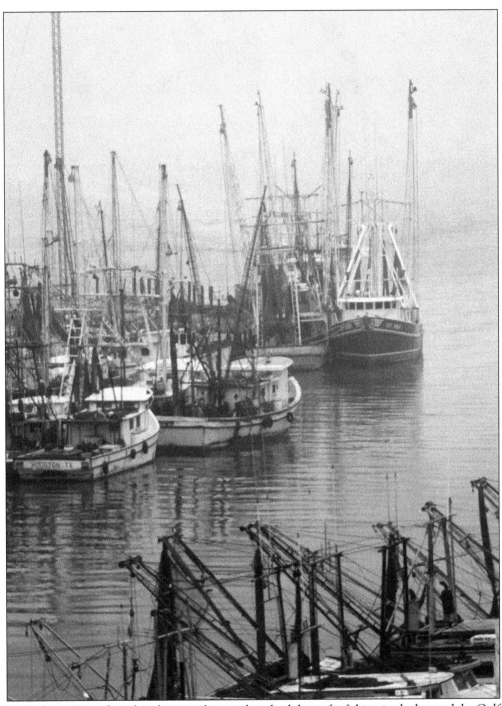

By the late 1980s, when this photograph was taken, both boats for fishing in the bay and the Gulf were docked in Seabrook. It all started around 1940, when a fisherman in Louisiana decided to put a net in the water at night. What he learned was that he could catch more shrimp at night, enough to make a living. Word spread all along the Texas Gulf Coast, and shrimping became a new industry.

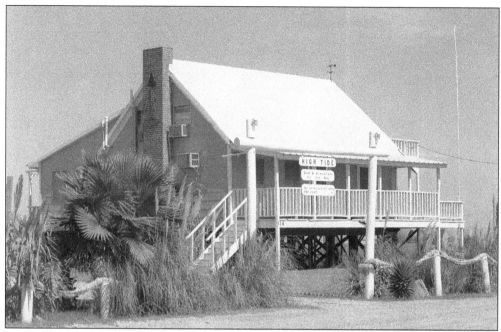

Dr. Walter Lipscomb built High Tide in 1937 on the "Point." It was a summer home for his family and his daughter, Mary, who as a child described it as being like her "mini king ranch." At the time, it was surrounded by bay homes of the wealthy Genoa and Kirby families from Houston. After Hurricane Carla in 1961, it stood alone and has since withstood both Hurricanes Alicia and Ike.

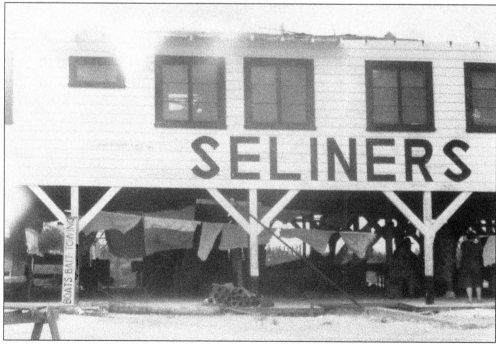

Down on the Seabrook Flats in the 1940s was a popular family-owned restaurant named Seliners and pronounced "Selinas" by the locals. (Courtesy Ratliff family.)

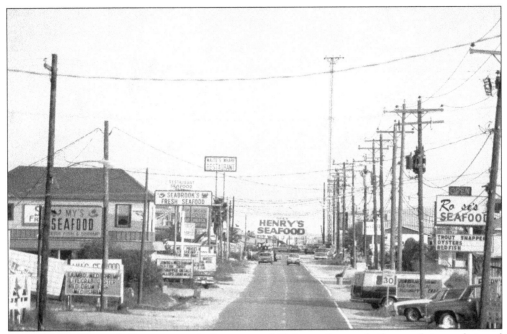

Up and down Eleventh Street, staunch shoppers unfold themselves and pile out of air-conditioned cars. Some strike out for their favorite fish market. Others splinter off. They flip-flop from fish market to fish market, inspecting the fish, looking for clear eyes, and checking for the best price. This photograph was taken in 1982, when Captain Wick's, Rosa's, My's, Foreman's, Henry's, and Emery's were among the popular places to shop.

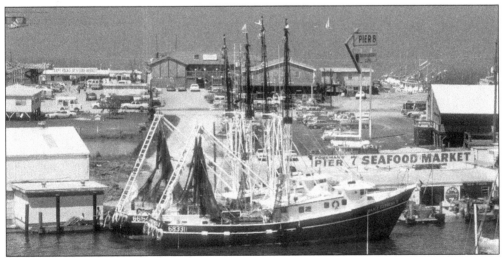

By 1986, most sold what they caught from their own boats fishing out of Texas and Louisiana. Foreman's Pier 7 was a family business owned by Don and Mary Foreman with their two sons. Mixed in are the Vietnamese seafood fishermen and retailers that came to Seabrook in the late 1970s, after the end of the Vietnam War. Seabrook was a perfect fit for these refugee fishermen.

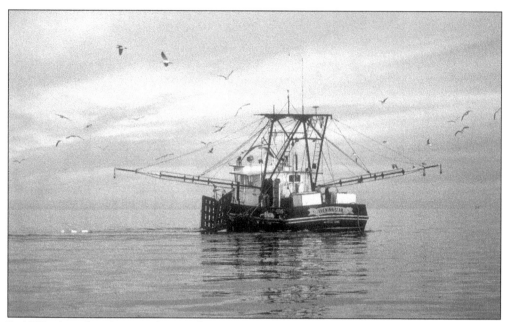

In 1987, when this photograph was taken, it was common to be able to watch the boats dragging their nets for shrimp while boating in Galveston Bay. Captain Wick owned this boat that he named *Evening Star*. He sold what he caught at his retail store on Eleventh Street in Seabrook.

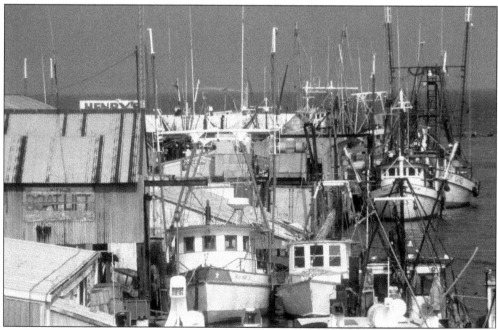

One of the first seafood retailers, Henry's prominently advertises its location on the "Point." The docks of Seabrook were packed with commercial fishing boats when this photograph was taken in 1978. The popular tasty Gulf shrimp from Texas were in demand in restaurants from San Francisco to New York.

Four

NASA AND
THE INCORPORATION
OF SEABROOK

In 1961, fearing annexation by the City of Houston and LaPorte, the local leadership decided to have the community known as Seabrook become a city. On October 14, 1961, the residents voted to incorporate with 198 votes in favor and 13 votes against. Seabrook covers more than 12.5 square miles, including choice waterfront property. The original city seal showed the waterfront, space exploration, and industry of Seabrook in illustrations.

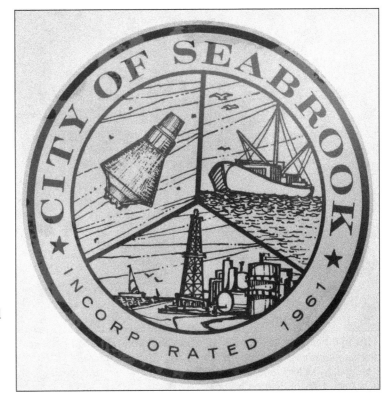

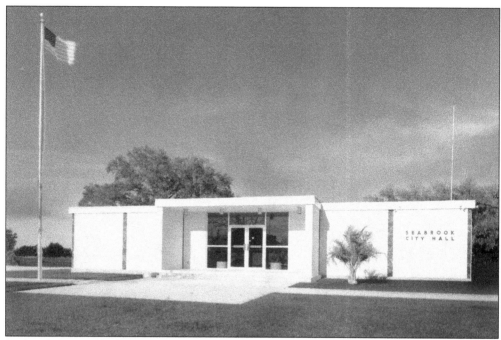

Seabrook City Hall is located at 913 North Meyer Road. This photograph shows the first building, which formally opened its doors on October 1, 1966. It was closed in 1994, and the offices were moved to Bay Elementary until the new city hall building was opened on April 1, 1996.

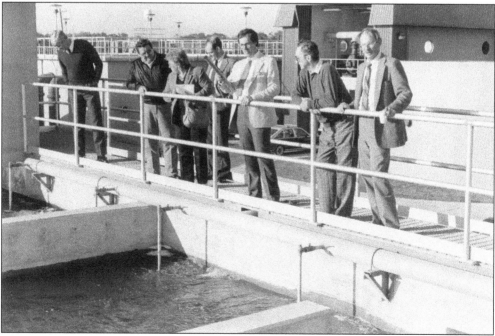

This photograph was taken in 1987 at the grand opening of the sewer plant serving Seabrook after a major upgrade. Pictured here are, from left to right, Mike Ringold, Bill Fuller, Annie Kuehnel, Mike McGhee, city manager Lanny Lambert, unidentified, and Mayor Helmut Kuehnel. (Courtesy City of Seabrook.)

W. P. Hamblen Jr. (above) became the first mayor of Seabrook. Hamblen served as mayor from 1961 to 1962. In addition, he was a district judge for Harris County and was also referred to as Judge Hamblen. In the Seascape I subdivision, Hamblen Street bears his name. Serving along with Mayor Hamblen were the following council members: C. R. Gale Jr., Pete C. Larrabee, Carl L. Fenity, Paul Cravey, and G. W. Robinson. C. R. Gale was a longtime resident and ship builder born on the banks of Clear Creek in 1909. Larrabee Street and Larrabee Cemetery, located off Lakeside Drive, are named after Pete Larrabee's family. (Courtesy City of Seabrook.)

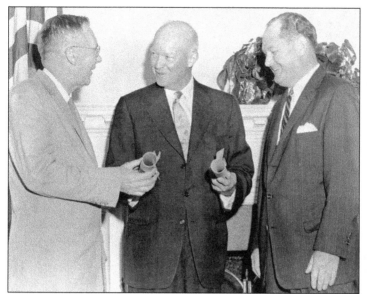

On October 1, 1958, NASA was created to perform research related to space flight and aeronautics. Pres. Dwight D. Eisenhower commissioned Dr. T. Keith Glennan, right, as the first administrator for NASA and Dr. Hugh Dryden as the deputy administrator. (Courtesy NASA.)

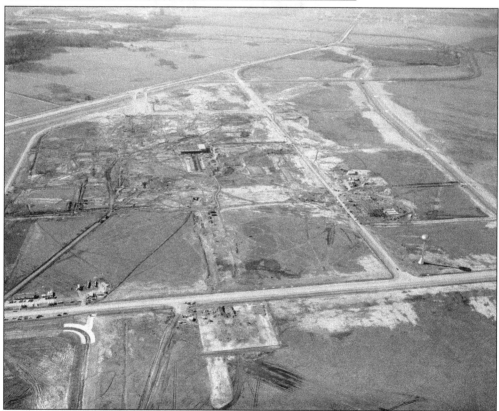

This aerial view of Site One, the manned spacecraft center, in 1963 during its early construction phase emphasizes the openness of the land extending all the way into Clear Lake and Galveston Bay. The unfinished red structure to the right of center is the Central Heating and Cooling Plant. In the upper left quadrant of the frame, construction appears very far along on the Central Data Office. (Courtesy NASA.)

Pictured is astronaut Edward White, who became the first astronaut to walk in space. Ed White was a member of the Seabrook Methodist Church and had a vision to build a youth center. During the Apollo mission on January 27, 1967, there was a flash fire, and Ed White, Gus Grissom, and Roger Chaffee lost their lives. In 1971, the Ed White II Memorial Youth Center opened in Seabrook. (Courtesy NASA.)

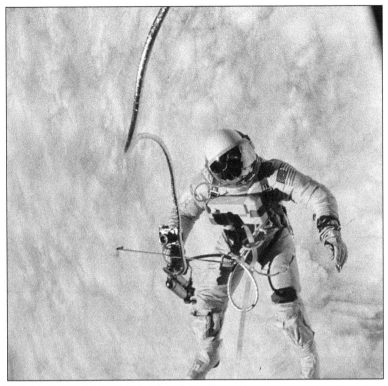

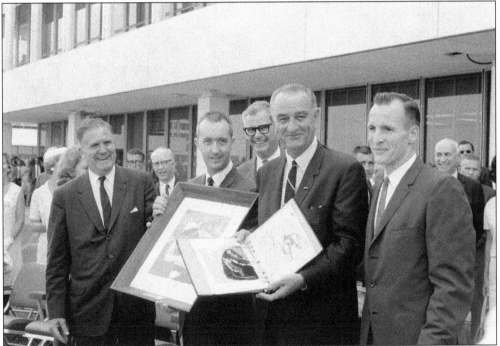

This photograph shows Pres. Lyndon Baines Johnson and astronaut James McDivitt (second from left) displaying photographs of astronaut Edward White and his historic extravehicular activity during the *Gemini 4* flight. (Courtesy NASA.)

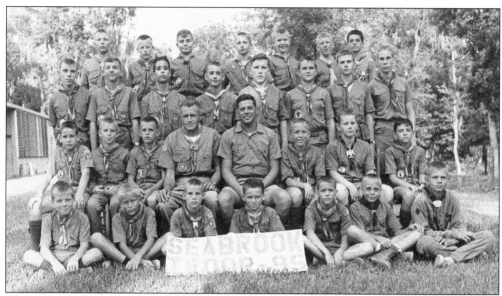

The Seabrook Boy Scout Troop No. 95 in the early 1960s is shown with Kenneth Royal as scoutmaster and Sidney Brummerhop as his assistant. In the first row, second from the right, is Scott Grissom Jr., the son of astronaut Scott Grissom, who was killed on the *Apollo 13* mission. (Courtesy Kenneth Royal.)

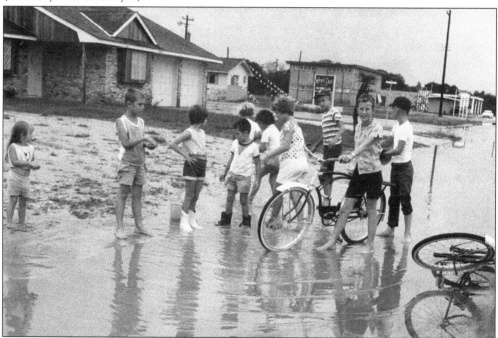

This photograph was taken in 1962 on Capri Lane in the Miramar subdivision. It was one of the first subdivisions developed in Seabrook by Rex Meador. He also developed Seascape I and II to handle the population increase from NASA. The children shown in this photograph are, from left to right, unidentified, John Stahl, Billy Jo (white boots), Craig (black boots), two unidentified, Genevieve Dickerson (white shorts), unidentified, Mark Millar (holding the bike), and unidentified. (Courtesy Genevieve Curry Dickerson.)

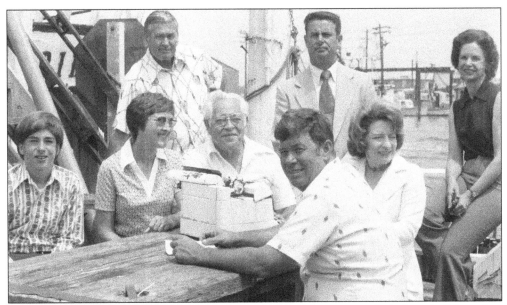

Former mayor and member of the Seabrook Bicentennial Committee, Jack Campbell (standing back left) is at the "Point" discussing the plans for a reenactment of the Boston Tea Party for the celebration. Also in the photograph are, from left to right, Don Holbrook, Ann Amsbury, Ed Dangler, Byrd Menard, Betty Brummerhop, and Eleanor Scott. The man in front is unidentified. (Courtesy City of Seabrook.)

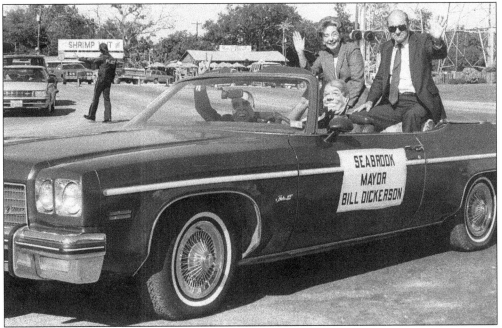

Bill Dickerson and his wife, Ginney, are shown in a political campaign parade for mayor in 1972. The driver and passenger are wearing masks of present and future presidents Richard Nixon and Ronald Reagan. The Shrimp Hut in the background was owned and operated by Frank and Nancy Jureczki, and it was known as the place to get the freshest fried seafood in town. (Courtesy Genevieve Curry Dickerson.)

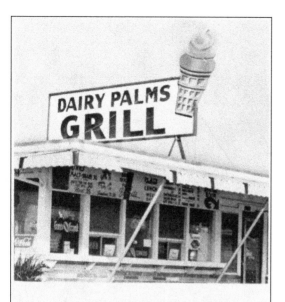

DAIRY PALMS
GRILL

HIGHWAY 146 SEABROOK

These are advertisements from the 1963 Clear Creek High School yearbook of popular businesses in Seabrook. The Dairy Palmss opened in 1959 and was located on Highway 146, south on NASA 1. In 1976, it was sold and became Tookies, a popular local restaurant that has remained closed since Hurricane Ike. (Courtesy Larry R. Roberts.)

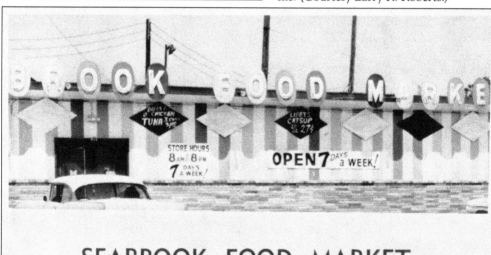

SEABROOK FOOD MARKET

SEABROOK

Open 8 a.m. to 8 p.m.

7 days a week

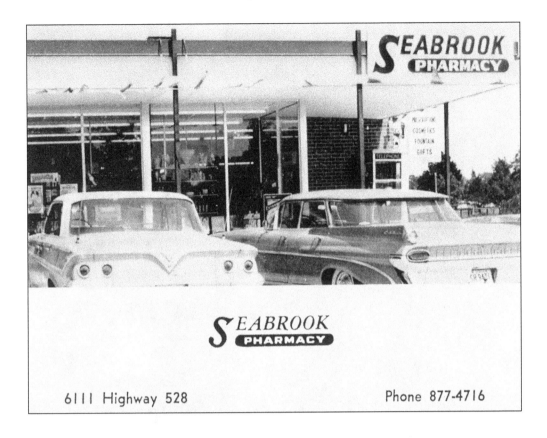

SEABROOK
PHARMACY

6111 Highway 528 Phone 877-4716

These are advertisements from the 1963 Clear Creek High School yearbook of popular businesses in Seabrook. In 1963, the Seabrook Pharmacy was the kind of place where one could chat with the pharmacist while having a prescription filled. It also sold arts and crafts made by local artists. Curry Sporting Goods was the first store to open in Seabrook exclusively devoted to selling fishing and hunting supplies. It was located on NASA Parkway near the entrance to Lakewood Yacht Club. It was owned by Fellow Curry, the son of Genevieve Bennett Curry, the owner of Curry's Food Market on Second Street. (Courtesy Larry R. Roberts.)

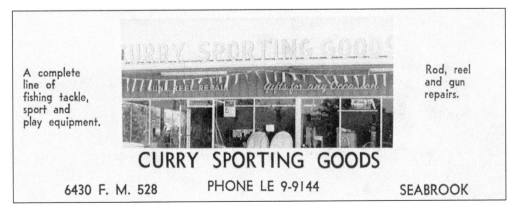

A complete line of fishing tackle, sport and play equipment.

Rod, reel and gun repairs.

CURRY SPORTING GOODS

6430 F. M. 528 PHONE LE 9-9144 SEABROOK

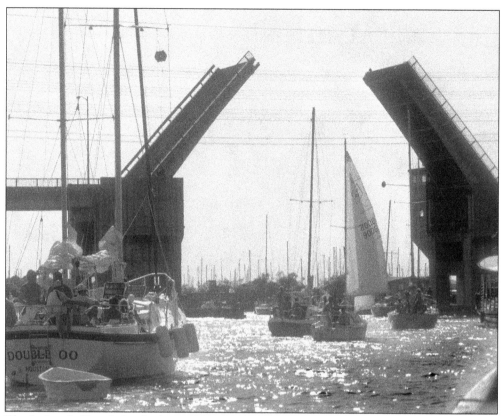

The Seabrook–Kemah drawbridge construction began in 1959 as a two-armed, elevated drawbridge. It opened in 1961 to rise above the Creek Channel, allowing for cars to travel from city to city while boats navigated the channel from Galveston Bay into Clear Lake. Occasionally, the bridge opened for sailboats with tall masts to go through. By the mid-1970s, the bridge's height was reduced due to subsidence, causing traffic congestion among motorists and sailboats alike. The bridge was replaced by a 75-foot-high fixed-span bridge in 1986. Pictured below is the sign that welcomed motorist traveling to Seabrook from Galveston to Harris County on the Seabrook–Kemah drawbridge in the 1970s and 1980s.

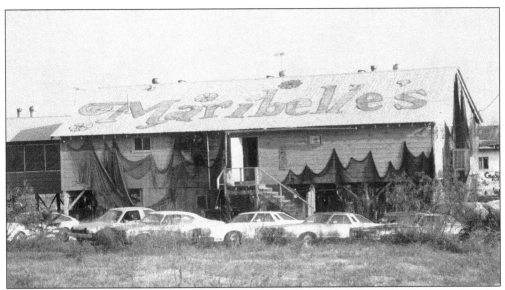

Maribelle's, located on Bath Avenue and Todville Road was named after its proprietor, Maribelle, a character as colorful as her pink honky-tonk. As the home of the Miss Wharf Rat Contest, it shared its pink notoriety with the astronauts of the 1960s and 1970s that graced her doors and wrote space travel notes on the napkins. The pink boards of the building were littered across Clear Lake after Hurricane Ike in 2008.

The Seabrook Hotel on Todville Road was known as Rachel's Place when this photograph was taken in 1979. Originally the Scoefield Hotel owned by Elton Porter's aunt, the building had 14 rooms and 3 baths. For years, Rachel McDowell entertained the who's who in Texas law every Sunday morning, producing her famous scrambled eggs with jalapeño peppers, tomatoes, and Fritos in a big well-seasoned cast-iron skillet.

Pictured here are members of the Seabrook Parks Board and Planning Committee. At the time, they were making plans for Pine Gully Park located off Todville Road and fronting Galveston Bay. From left to right are Kenneth Royal, Emogene Brummerhop, Dave Fosdick, and Anna Kuehnel. (Courtesy City of Seabrook.)

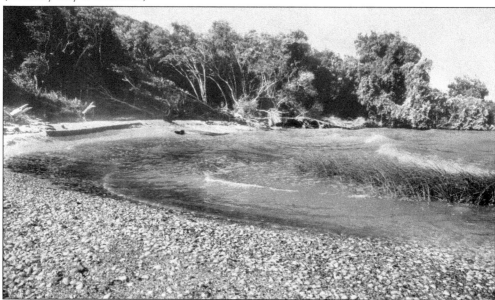

Pine Gully Park was once a Native American settlement for the Karankawas. To survive, they ate fish and clams from the bay. After taking out the clam, they deposited the shells, creating shell middens that appear as heavy collections of shells forming a shell beach along the coastline. As shown in this recent photograph, the shell middens are still visible, depending on the tide in Pine Gully Park.

Drusilla Carothers Coastal Gardens, north of Pine Gully Park, was purchased by Durell Carothers and his wife, Grace, in 1954. They called it C-Acres and used it as a bay side retreat. The original buildings were remodeled in a hacienda style in the 1990s to celebrate the area's early Spanish land grant history. Drusilla died in 2003, and in 2007, the voters of Seabrook made the estate a city park. (Courtesy Sally E. Autrobus.)

Maas Nursery, located on Todville Road where Pine Gully feeds into Galveston Bay, was started by Herbert and Winnie Maas in 1951. It grew over the next 20 years to encompass 14 acres. The location was chosen because the soil was good for growing a variety of plants. Jim and Carol Maas, shown in the photograph, continue the legacy of operating a nursery that is visited by people from both far and near.

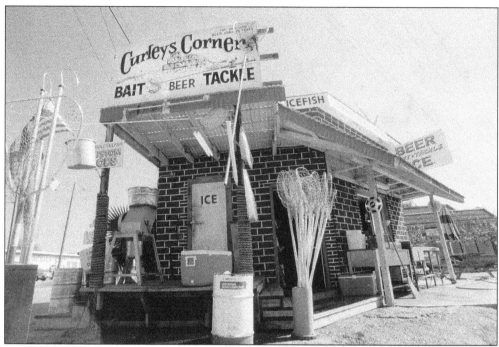

When Robert Hooker died in the early 1950s, his little ice and bait shop was sold to Fred Horlock, a distributor for Pearl Beer. Horlock then leased it to a man known only as "Doc," who renamed it Doc's Ice House and stayed in business for the next 15 years. Selling beer and bait to fishermen heading to the bay to fish made this little icehouse a popular spot. The next owner who gave it the name that stuck was "Curley" Forman.

The owner of this nostalgic little building when this photograph was taken in 1992 is Alan Thayer. A lover of Central Mexican art, he brought a new look to this little monument in the middle of the road. He made each side of this triangular building different, adding mission-style bells from Guanajuato, lanterns from San Miguel de Allende, a Mexican saint from Zacatecas, and interesting cacti native to Texas.

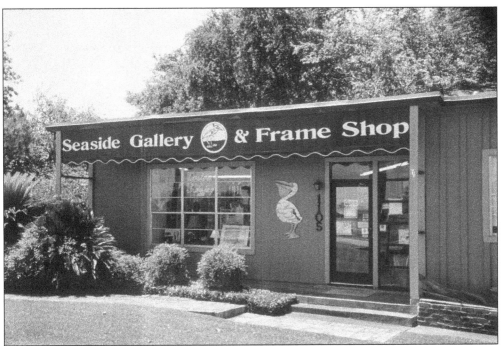

In 1989, Ruth Burke opened her first gallery in the Old Seabrook District at 1105 Second Street in the historic Harral home. She began her career photographing the changing waterfront scenes of Seabrook in the 1970s and 1980s. The waterfront location was an inspiration for many of her historic images. In 1999, she expanded to a new location at 204 Kirby Road. The original building on Second Street was destroyed by the storm surge from Hurricane Ike in 2008.

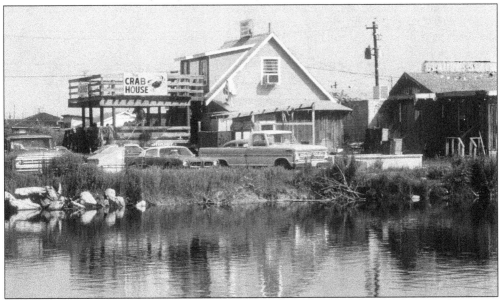

Across from Seabrook Flats, at the corner of Tenth Street and Todville Road, is a building that boasted a barefoot dining experience. When this photograph was taken in 1979, it was known as Sammon's Crab House, where munching on the famous, cooked-to-perfection Texas blue crab was enjoyed. Hurricane Ike in 2008 destroyed this landmark of Seabrook's seaside history.

In 1990, when the historic Burns Market building was scheduled to be torn down, Marian Kidd (pictured in a white hat above) rescued it and had it moved to its new location at 909 Hall Street in the Old Seabrook District. The building was constructed in 1924 as a general store and home and was located on NASA Parkway near Highway 146. Marian, remembering her days growing up in Seabrook, treasured each nook and cranny of the cottage homes that she bought. She lovingly restored each one, turning them into charming places for thriving small retail stores. She did the same with the Burns Market building, adding the large porch seen below, reminiscent of the one the original structure had. It became the center of her Back Bay Market held every month in Seabrook. Joy Jowell, who ran her potpourri and dried flower business from the building in the 1980s, said about the old building especially during a storm, "It has a very calming presence. I see it as an oasis." (Both, courtesy Robert and Marian Kidd.)

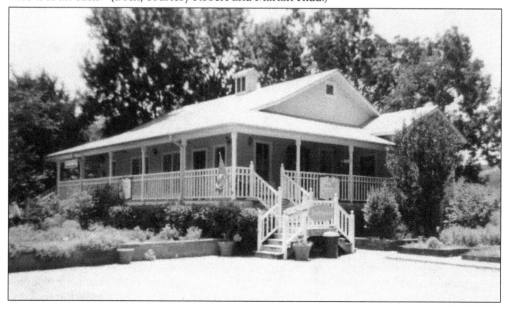

If only the walls could tell the stories of one of the oldest houses in Seabrook, located at 913 Meyer Road. It was built by Ansel Wiltsie in 1890 for his wife, Etta, who became the first librarian in Seabrook when, in 1906, the first library was started in the front room of the Wiltsies' home. The house later became the home of George Ballentine. Ballentine always had a very lush garden. Here he is seen standing in front of his house with wife, Buena, in the 1960s. In 1979, the home was purchased by the Harral and Kidd families. They restored the home, and it became one of the first businesses in the Old Seabrook District that was started in 1989. Since then, the house has been used for the Seabrook Visitor Center and is currently used for the Bay Area Houston Convention Center and Visitor Bureau. (Right, courtesy David Fosdick; below courtesy City of Seabrook.)

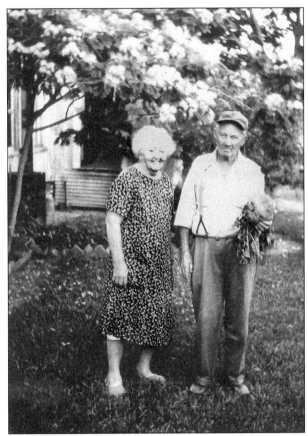

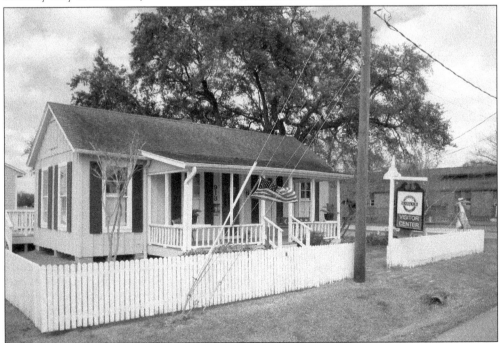

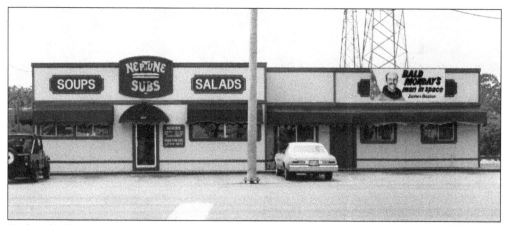

Seabrook Classic Café and Neptune Subs, pictured above, are popular eateries with the locals. The Seabrook Classic Café, owned by Brad Emel, opened in 1984 on NASA Parkway. Vinny Schillaci opened Neptune Subs in the late 1970s. It is located at the busy intersection of El Mar Street and Highway 146 next to the railroad. As an Italian coming from New York, Schillaci longed for the familiar Sicilian sub that he grew up eating. Thus, he took it upon himself to offer the best subs in a 20-mile radius. Every Monday, Neptune's celebrates "Bald Monday," where those that are bald get a discount based on their baldness. (Courtesy Vinny Schillaci.)

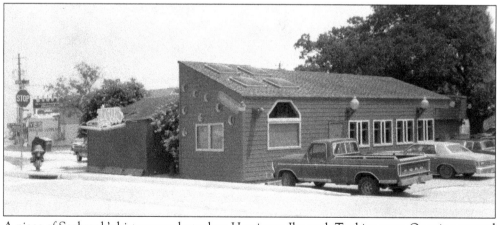

A piece of Seabrook's history was lost when Hurricane Ike took Tookies away. Opening around 1976 in the building that was the Dairy Palmss, a popular spot in the 1960s, they transformed this little building into a unique dining experience noted to be among the top 10 hamburger joints in the United States. It has been said the No. 99 on the menu was happiness with beef and that the onion rings were superb. (Courtesy City of Seabrook.)

Five

PLAYGROUND FOR PLEASURE BOATERS

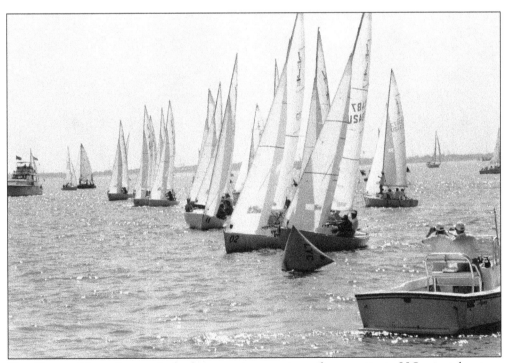

The Harvest Moon Regatta is the largest point-to-point sailing regatta in U.S. coastal waters. Started in 1987 by John Cameron, John Broderick, and Ed Bailey, it has attracted as many as 250 sailboats and 2,000 sailors each year to race a distance of 153 offshore nautical miles from Galveston to Port Aransas, Texas. This photograph shows the start of the spinnaker class of sailboats in the race. (Courtesy LYC.)

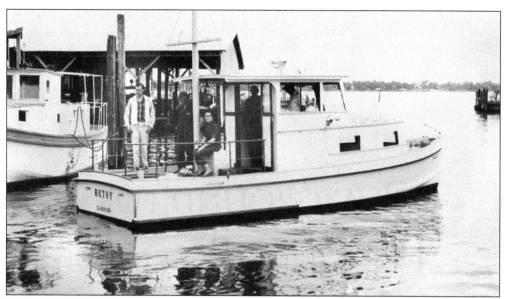

Cooter Gale made this pleasure cruiser for Judge Hamblen, Seabrook's first mayor. He built it at his shop in Seabrook, where he also made many of the shrimp boats used in the area. The photograph was taken in 1968 with the judge's son, Bill (in light-colored jacket), and his wife, Betsy (sitting), on the boat as they begin to motor in Taylor Bayou. The judge is inside the cabin driving the boat. (Courtesy Leslie Gale.)

ERN was a family boat built by Gus Meyer, a prominent local resident who worked as a sales manager for Howard Hughes. In this 1940s photograph, enjoying an outing on Galveston Bay are, from left to right, Margaret Brazda; Joan, Eleanor, and Jeanette Meyer; and "Mama" Lillian Meyer. (Courtesy Eleanor M. Scott.)

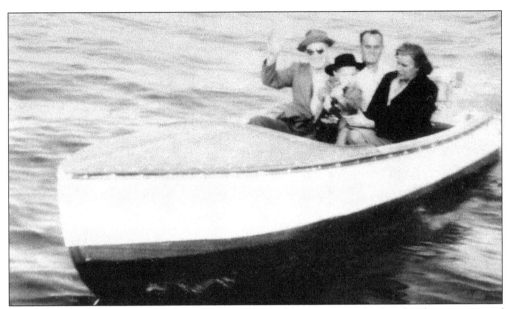

Beginning in the 1930s, pleasure boating became a popular activity in Seabrook. The waterways of Taylor Bayou, Clear Creek, and Clear Lake offered boat docks and launch facilities for powerboats. Visitors from Houston began to keep their boats in the local marinas for easy access to the water. This was the beginning of a multimillion-dollar boating industry that would shape the economic future of Seabrook. (Courtesy EML.)

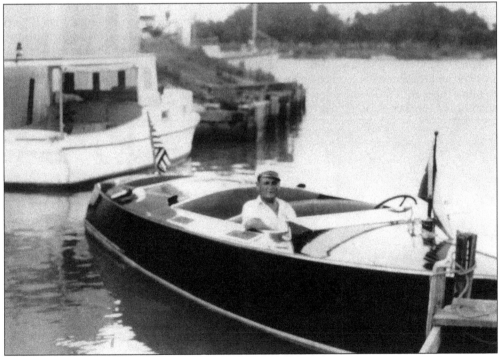

This vintage watercraft motoring in Taylor Bayou is constructed out of wood, the primary material that boats were made from for customers at the different boatyards in Seabrook. (Courtesy EML.)

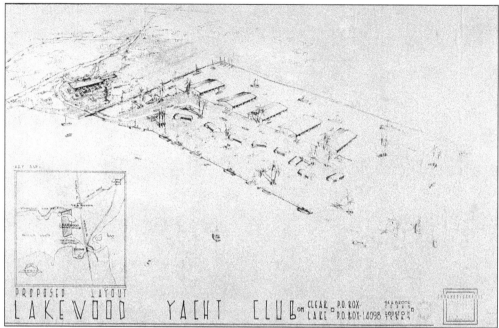

This is the original drawing of Lakewood Yacht Club. Located on the northeast corner of Clear Lake, Lakewood Yacht Club officially opened its doors on August 19, 1955. After World War II, there were only two yacht clubs on the Texas Gulf Coast: Houston Yacht Club and Texas Corinthian Yacht Club. Both of these clubs catered to sailboat owners. Powerboat owner Sterling Hogan Sr. was a land developer who owned 40 acres of land adjacent to Ben Taub's old Rouger Hotel property on Clear Lake, however, it did not have access to the water. He, along with two other prominent businessmen, wanted to build an elegant yacht club that would cater to powerboat owners. A land swap was made with Ben Taub, allowing for water access. Construction began in 1954, and the Bermuda-style clubhouse was finished in 1955. In 1973, the members decided to allow those with sailboats to join the club, a decision that would lead to the club being the sponsor of a number of sailing regattas. (Both, courtesy LYC.)

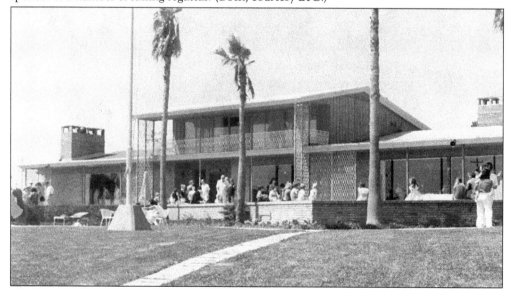

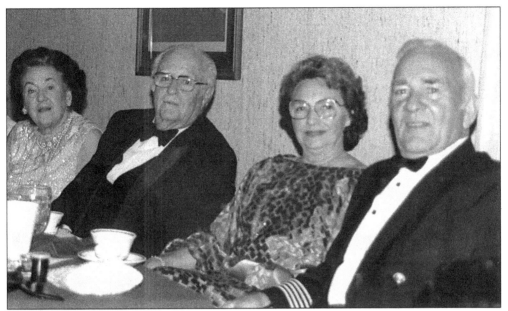

On the left is Maggie Plumb DeNike with her husband, Jack DeNike. Maggie was the founder of the Lunar Rendezvous Festival, which included a boat parade from Lakewood Yacht Club through the Clear Creek Channel to Galveston Bay and back. On the right are Seabrook residents Lois Mohrhausen, who was appointed chairman for the festival in 1975, and her husband, Fred Mohrhausen, past commodore of Lakewood Yacht club. (Courtesy LYC.)

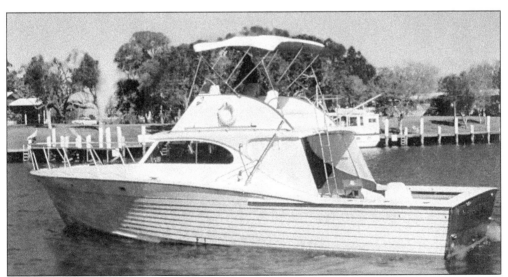

The *Helen Be Good* was a 1959 enterprise owned by member and financier Walter Hall. She was one of the first fiberglass boats in the Clear Lake area, built by using a state-of-the-art technique that involved bonding fiberglass over a plywood hull and deck. She was docked at Lakewood Yacht Club. (Courtesy LYC.)

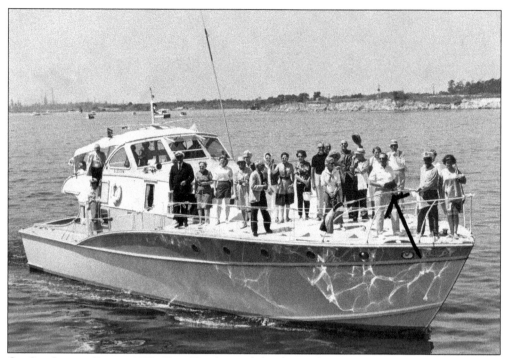

On San Jacinto Day in 1959, Tom Tirados took his boat *Electra* cruising in the Houston ship channel in the vicinity of the San Jacinto Monument with a large group of friends. Tom kept his boat at Lakewood in C shed. (Courtesy LYC.)

The west side of the Lakewood Yacht Club property had a crab dock before the West Harbor was constructed. This photograph shows the sparse collection of homes on the south side of Clear Lake in the early 1960s. (Courtesy LYC.)

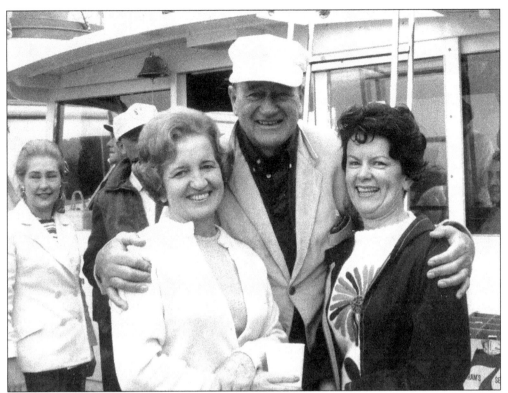

John Wayne was a visitor at Lakewood Yacht Club when he was a guest of Commodore Bill Dickey, who took him aboard his boat *Avalon* for several cruises while he was in town with a movie company. He is pictured with Betty DeMontrond (left) and Nan Allen. (Courtesy LYC.)

Roberta, a 60-foot feadship, was constructed in Alkmar, Holland, in 1954 by Lakewood Yacht Club member Jack Younger's grandfather, Edgar. She was constructed with a steel hull with fiberglass to withstand deterioration from rust and corrosion. The upper deck was constructed solely of teak. She was one of the first large yachts docked at Lakewood and remained there until 1969. (Courtesy LYC.)

Lakewood Yacht Club members Donna and Rich Reiling purchased *Flying Lady*, a 1937 Mathis-Trumpy, in 1997. Docked at the yacht club, she is a 61-foot vintage vessel that has been fully restored, receiving many honors, including the Keels and Wheels Concours d'Elegance 1998 Best of Show, Best in Class, and People's Choice awards. (Courtesy LYC.)

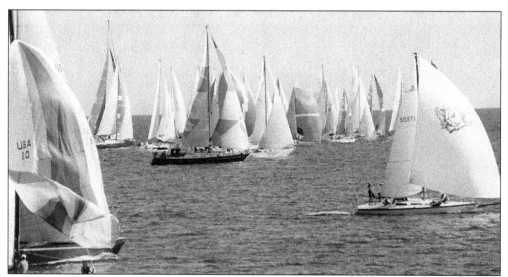

In 1982, Bob and Rubye Garrett and Ed Matthews, members of Lakewood Yacht Club, met with representatives from Sperry Topsider shoes and Foley's Department Stores to develop a sailing regatta in which the winning skippers and crew would receive Sperry Topsider shoes as trophies. The Foley/Sperry Regatta was born, the first race taking place in 1982. Over the years, it has been nicknamed the "shoe regatta." The starting line of the J22 class is shown in the photograph. (Courtesy LYC.)

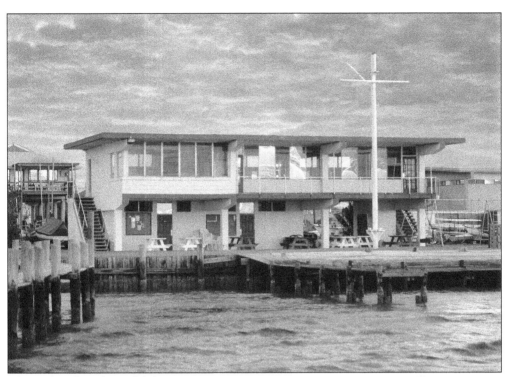

The Seabrook Sailing Club became official in December 1955. In the 1940s, a group of sailors noted that their main goal was in promoting interest and active participation in sailing and the education of club members. This effort resulted in acquiring small parcels of property in the area of Fourth Street and Bath Avenue in Seabrook to locate the club. Windsurfing, as shown in the photograph at right, is enjoyed by many of its members. Hurricane Alicia, in 1983, knocked out the ground floor of the clubhouse that is shown in the above photograph. The bottom floor was rebuilt in 1984. Hurricane Ike delivered a devastating blow to the clubhouse September 12–13, 2008. A new clubhouse is now under construction in 2010. (Above, courtesy Chris Kuhlman.)

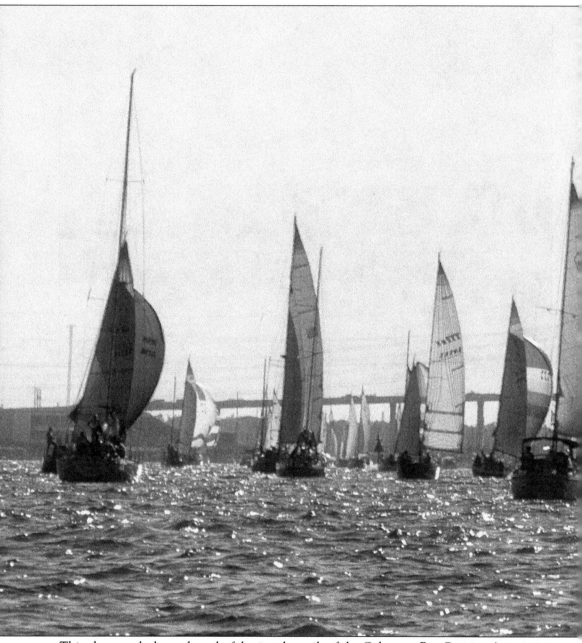

This photograph shows the colorful spinnaker sails of the Galveston Bay Cruising Association (GBCA) racers on Galveston Bay. The GBCA began in 1947 with a small group of sailboat racing enthusiasts. In the beginning, the fleet was divided into three classes: one for racing hulls, one for cruising hulls, and one for boats that did not fit either of these classes. Since that time, rating systems and classes have changed, but the club still holds true to its original concept of

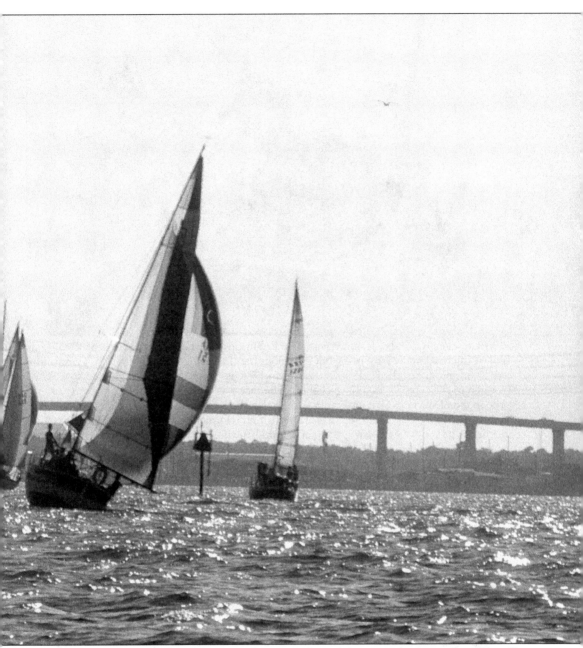

promoting the racing of sailboats. In 1948, the group adopted the present name and was formally organized in 1954. In 1975, it was incorporated as a nonprofit organization. GBCA has been one of the leading sailing clubs in Texas, and its members have competed and won honors on both national and world levels.

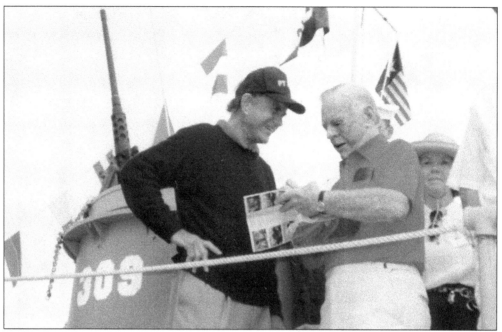

Seabrook resident Red Adair is shown with Cliff Robinson at the Lakewood Yacht Club. Red Adair is known internationally for putting out enormous life-threatening oil well fires and controlling blowouts. He promoted the Fizzle 500 boat race in 1971, as shown in the photograph below. Adair is pictured in the center with a life jacket on. The race was for boats with 20 horsepower or less. At the sound of the gun, all contestants were to pop the top of a can of beer and drink it before starting their engine. Also pictured in this photograph is former Seabrook council member C. W. Schoellkopf, at left, walking down the pier toward his wife, Marilyn, far right looking back into the water, and their son, Lyle. (Above, courtesy LYC; below, courtesy C. W. Schoellkopf.)

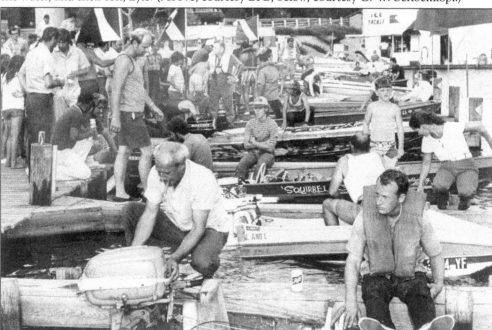

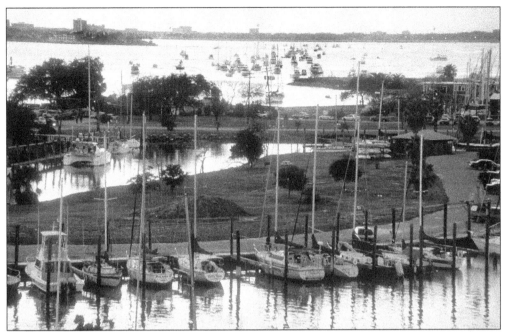

Looking west from the fixed-span elevated bridge between Seabrook and Kemah is Seabrook Marina, formally called Seabrook Shipyard. This photograph was taken on the evening of the Christmas Boat Lane Parade in December 2002, when spectator boats gathered in Clear Lake to watch the parade.

Around 75 percent of the boats docked at the Seabrook Marina are sailboats. Twenty-five percent are powerboats with an average length of 50 feet. The 1940s repair yard building is still used and is shown in this photograph.

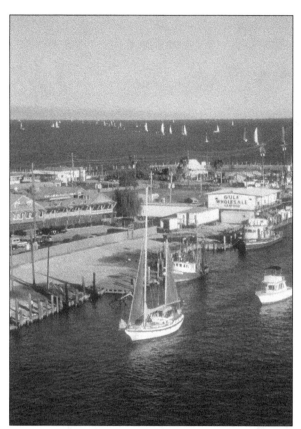

This photograph shows popular restaurants and boat docks that were on the waterfront of Seabrook before the destruction from Hurricane Ike in 2008. The horizon is dotted with boats as they make their way into the Clear Creek Channel.

It was a common sight to watch the traffic of pleasure boats, along with commercial fishing boats, as they entered the Clear Creek Channel from Galveston Bay at the "Point" in Seabrook.

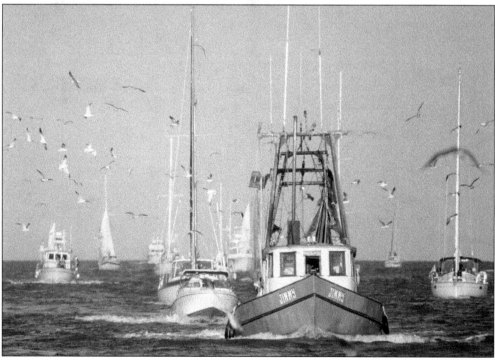

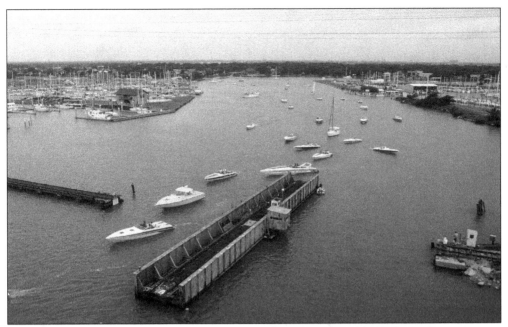

Boats from the Texas Offshore Performance Powerboat Squadron (TOPPS) are shown starting to form a line to motor under the bridge for a Poker Run event. Member boats have to be no less than 21 feet in length and run in excess of 50 miles per hour. This photograph was taken before the railroad swing bridge was removed in the early 1990s.

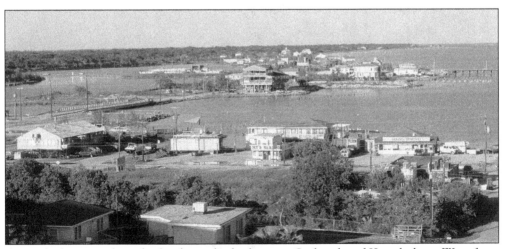

A view looking east from the fixed-span bridge between Seabrook and Kemah shows Waterfront Drive, or Eleventh Street, and Todville Road as it was in 1998. In September 2008, Hurricane Ike changed the landscape with its 17-foot tidal wave that swept over the area. The far left building was the legendary Maribelle's bar.

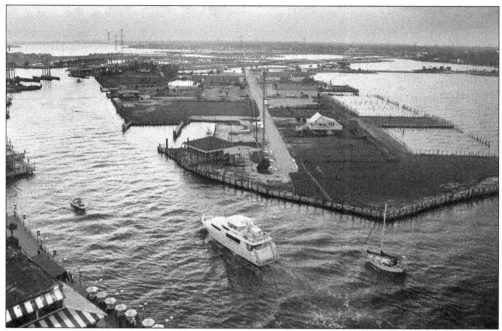

This photograph was taken in June 2010 overlooking the "Point" on the Seabrook waterfront. When Hurricane Ike came ashore in 2008, it damaged most of the buildings in this area. Since, they have been removed and new structures are going up. At the time of this writing, Waterfront Drive is to be developed with lighting and sidewalks for pedestrians. (Photograph by Ruth Burke.)

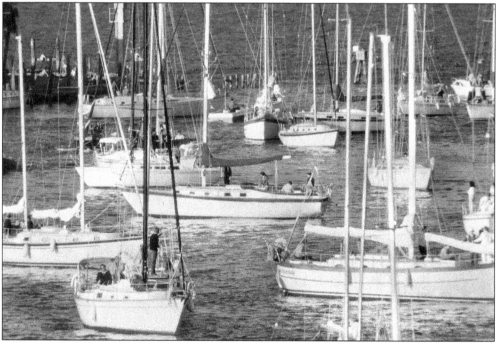

The congestion of sailboats in the Clear Creek Channel, as seen in this 1980 photograph, was a common sight on the weekends. It became a navigation nightmare for 30-foot and longer sailboats to maneuver the narrow channel while waiting for the bridge to open.

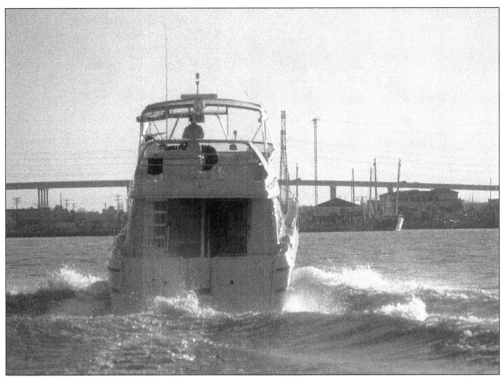

A common sight on Galveston Bay is shown in this photograph of a large power cruiser heading home with the bridge between Seabrook and Kemah in sight.

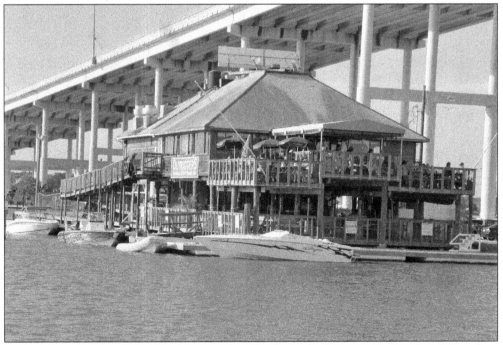

Outriggers is a Seabrook landmark. Located under the bridge between Seabrook and Kemah, it offers a front row seat for watching boats as they motor from Clear Lake into Galveston Bay.

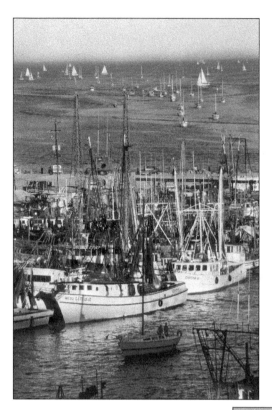

In the 1990s, commercial shrimp boats were docked up to three deep on the Seabrook waterfront. In contrast, pleasure boats of all kinds are shown cruising in Galveston Bay.

The pelican has become a symbol for Seabrook. All along the coastlines, pelicans can be seen hanging out on piers. The brown pelican stays year-round, while the American white pelican migrates to Seabrook in the fall and leaves in the spring.

Six

HAPPENINGS AND EVENTS

The Annual Ballunar Festival is held each year on the Johnson Space Center grounds. The skies over Clear Lake are transformed into a sea of color. Hot air balloon competitions, skydiving exhibitions, arts and crafts, and various aviation equipment are on display.

In 1996, an extraordinary event was launched at the Lakewood Yacht Club by past commodore Bob Fuller and Paul Merryman, namely the Keels and Wheels Concours d'Elegance. Boat and car collectors and enthusiasts from all over the world attend this exhibit to see specimens from some of the finest private collections, all displayed under the stately oaks on the grounds of Lakewood.

At the 2007 Keels and Wheels Concours d'Elegance, Carroll Shelby (center), famous race car driver and designer of the Cobra and Shelby Mustang cars, was present. He is shown with legendary race car driver Sir Sterling Moss (left) at the award ceremony. (Courtesy Timothy D. Miller.)

This photograph shows the notable ladies of Seabrook who were present for the celebration at the opening of the fixed-span bridge in 1986. They are, from left to right, Pat Harral, Genevieve Curry, unidentified, Winnie Christy, Mrs. Brown, and unidentified. (Courtesy Genevieve Curry Dickerson.)

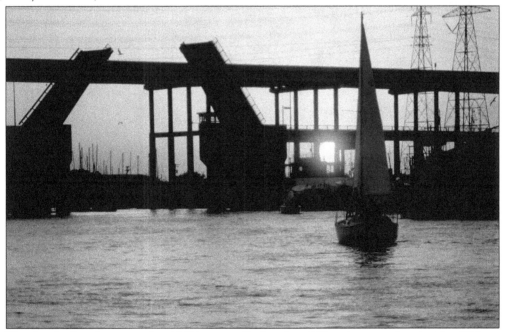

The drawbridge that opened in 1962 between Seabrook and Kemah was replaced with a 75-foot-high fixed-span bridge in 1986 to relieve the traffic congestion among motorists and sailboats alike. This photograph of both bridges together was taken in 1986 before the drawbridge was dismantled and reassembled in Louisiana.

Former mayor Joe Pirtle, aiming to promote Seabrook and attract people to the area, proposed celebrating the first 20 years of incorporation as a city. The first Seabrook Celebration was held on October 17, 1981. It featured a parade with more than 100 entries and astronaut Bob Crippen serving as grand marshal. The Seabrook Association then made this an annual event, with a parade, food, rides, and craft booths providing fun for all. The above photograph shows the drawbridge float in the parade. The celebration also featured an arts and crafts show, carnival rides, and a stage for performances by the children of local residents. Monica Burke (center) was part of the performance about space travel, as shown in the photograph, at right, taken in 1986.

Members of the Seabrook
Association spent many
hours during the fall
getting the association's
boat float ready for
the annual Seabrook
Celebration parade
before the float was
retired in 1986. Emogene
Brummerhop is on
the ladder, with Lynn
Miller (left) and Jan
Brown in the boat. "Big
Tim," a local artisan,
is shown standing in
front of the boat.

Gumbo Gull became the mascot
for the Seabrook Celebration.
The Seabrook Association used
the proceeds from the celebration
to provide playground equipment
for Bay Elementary, as well as
making financial contributions to
the Ed White II Memorial Youth
Center and the Fireboat Fund.

Judge Joe Pirtle served on the Seabrook City Council for four years, from 1969 through 1974, and was mayor of Seabrook from 1978 to 1980. Since that time, Pirtle has served as Seabrook's judge for all but one year. Pictured here are, from left to right, Jessica Ancira, Sharon Hill, Judge Joe Pirtle, Karen LeMay, and Ramona Flores. (Courtesy City of Seabrook.)

Celebrating the ground-breaking for the new library in 2010 are Friends of the Library members. From left to right are John Chisler, Mike Landolt, commissioner Sylvia Garcia, librarian Greg Burns, Mayor Robin Riley, director of Harris County Library Administration Rhoda Goldberg, president of Friends of the Library Marianne Kolar, and Tom Diegelman. (Courtesy City of Seabrook.)

The Texas Art Education Association (TAEA) has sponsored the Visual Arts Scholastic Event (VASE) since 1994. VASE is the only art event of its kind in the nation. Students are provided the opportunity to bring artwork created in their art classes to a regional event. Seabrook is a significant art community and was a major sponsor for the event in 2006, 2007, and 2008. (Courtesy City of Seabrook.)

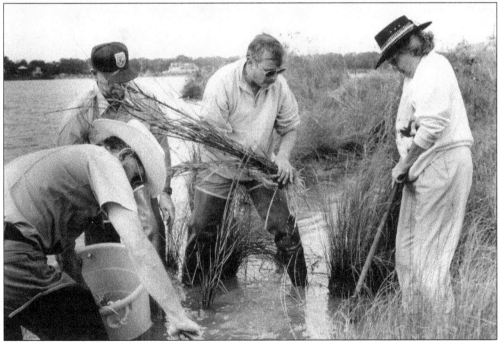

During her term from 1990 to 1993, councilwoman Lois Mohrhausen, shown on the right, was instrumental in organizing the planting of sea grass for the shrimp hatchery in the slough, a low-lying, water-filled area that feeds into Galveston Bay. The sea grass protects the sea life while they are spawning, and it also acts as a filter to the ecosystem to keep the water clean. (Courtesy Lois Mohrhausen.)

The Pelican Path Project was started in Seabrook in 2000 by Sherry Smith and Marcy Fryday. Since Seabrook was known for the many American white pelicans that migrate to Seabrook in the winter and the year-round brown pelicans hanging around on the piers, the pelican became a symbol for the city. Each pelican statue has a different and colorful theme, and they can be found all around the city—a total of 45 to date.

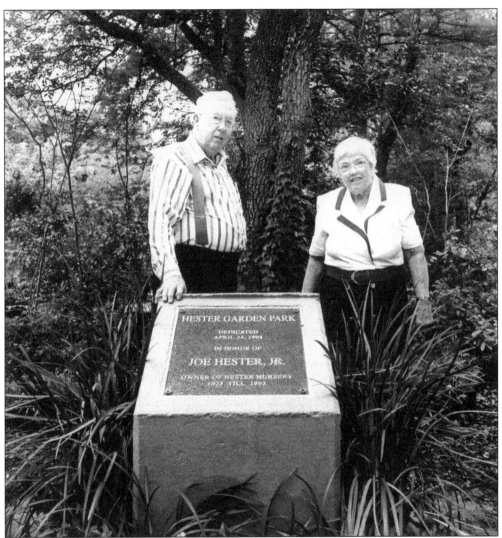

Doris Bennett married Joe Hester, an environmentalist and wildflower and coastal flora devotee, and together they opened Hester's Nursery on Todville Road in 1925. Their home was located across the road fronting the bay on the property that his father bought in 1914 from John G. Tod for $325. The Hesters dedicated the property to the City of Seabrook in 1994 as a garden park. The park features a butterfly garden, walking trails, and an ancient stand of bamboo. (Courtesy Chris Kuhlman.)

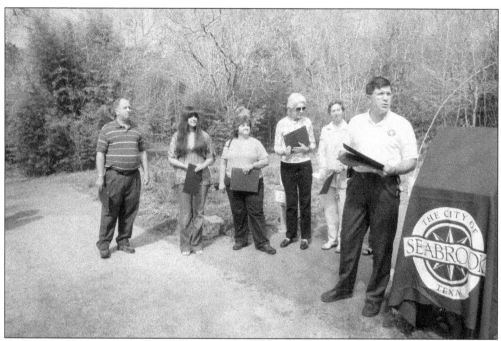

The dedication of the Butterfly Garden kiosk at Hester Park was held during the Coastal Photo Workshop in March 2007. Pictured are, from left to right, park board member Don Holbrook, Kimberly L. Jones, Ruth Burke, ecotourism members Dori Nelson and Sara Thompson, and Mayor Robin Riley.

Beginning in 2007, Domino Taylor, tourism director for Seabrook, coordinated with Ruth Burke, a local artisan and photographer, to sponsor a photograph workshop in Seabrook. The workshop featured field photography of the nature trails, marinas, coastal areas, and bird wildlife in Seabrook. Ruth provided guidance on using equipment and digital computer instruction. The photograph shows her 2008 group as they take pictures at the Seabrook Marina.

A former mayor of Seabrook and founder of Gulf Coast Limestone, Bill Robinson (sitting) is at his birthday celebration with past and present mayors. From left to right are Jimmy White, Jack Fryday, Joe Pirtle, Bill Dickerson, Robin Riley, and Bill's son, Bob Robinson. (Courtesy Genevieve Curry Dickerson.)

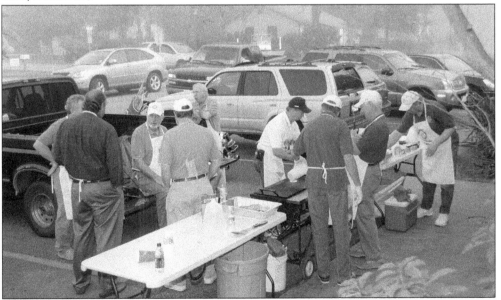

An annual tradition at the Seabrook Community House was the "Breakfast with Santa" event. Shown here are members of the Seabrook Rotary, who are always willing to lend a helping hand during community events. (Courtesy City of Seabrook.)

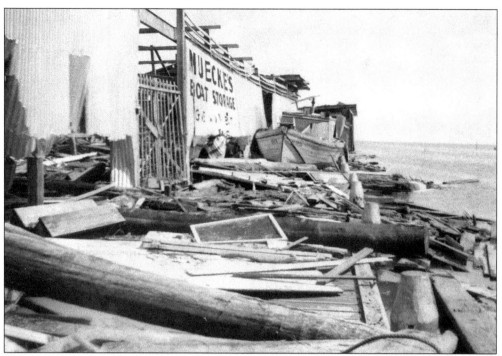

The second storm of the 1941 Atlantic hurricane season was a big one. It came ashore around Matagorda, Texas, during the afternoon of September 23. As the eye passed, the barometric pressure fell to 971 megabars—the lowest recorded in association with a hurricane at the time. Winds along the Texas coast reached up to 100 miles per hour. Seabrook had major damage to the waterfront area. Shown in the above picture is Muecke's boat storage after the storm, and shown below is the tidal surge over Todville Road.

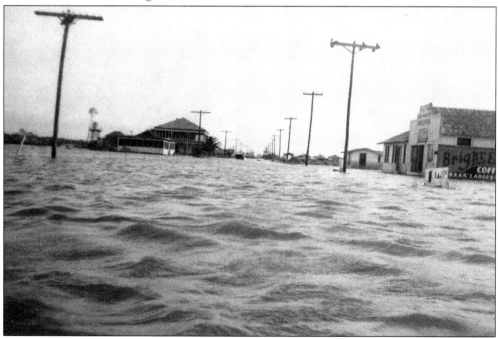

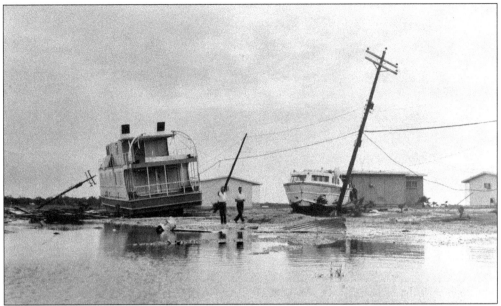

One of two Category 5 storms in 1961, Carla struck the Texas coast as a Category 4 hurricane. Landfall was between Port O'Connor and Port Lavaca on September 11, and Carla was the largest hurricane then on record. Little-known newsman Dan Rather reported live from Galveston, making his name as a broadcaster. Carla killed 43 people, with 31 being in Texas. The storm surge was measured at 22 feet at its highest point. (Above, courtesy LYC.)

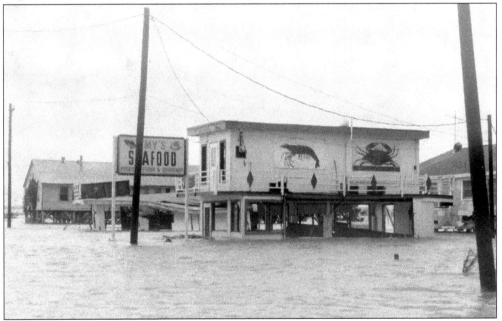

Hurricane Alicia made landfall on the west end of Galveston Island on August 18, 1983. The highest sustained winds were 96 miles per hour, with gusts of up to 127 miles per hour. During Alicia, 23 tornadoes were reported, 14 occurring between Galveston and Houston, and 21 people died due to the storm. Pictured here is My's Seafood on the "Point" as the water from Alicia came ashore. (Courtesy City of Seabrook.)

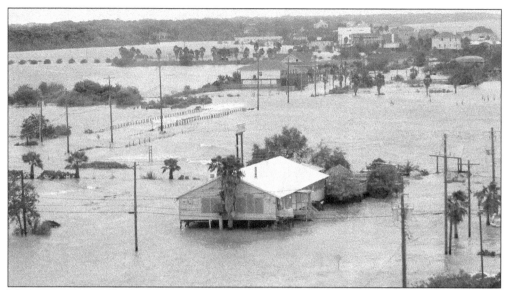

The popular Seabrook honky-tonk Maribelle's is shown in this photograph preceding the landfall of Hurricane Ike on September 13, 2008. Maribelle's was completely destroyed when the storm was finished. The pink boards from the building were found as far away as the south side of Clear Lake. (Courtesy City of Seabrook.)

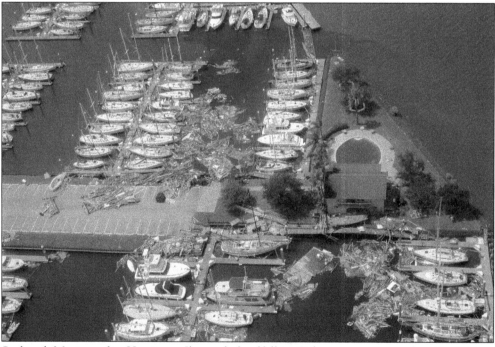

Seabrook Marina, after Hurricane Ike made landfall in Galveston on September 13, 2008, at 2:10 a.m., is photographed from above. Although classified as Category 2 for wind speed, Ike had the storm surge of a Category 4 storm. It was a huge hurricane, with tropical storm force winds extending 275 miles from its center. Landing on a populated section of the coast meant heavy destruction. Damage estimates are placed at $18 billion, making Ike the fourth costliest hurricane in the United States. (Courtesy City of Seabrook.)

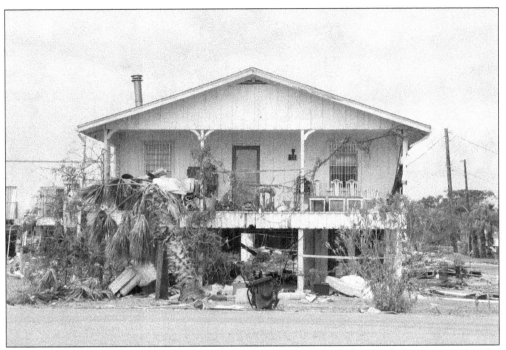

In the aftermath of Hurricane Ike, there were houses along Todville Road that appeared to be decorated for a horror movie.

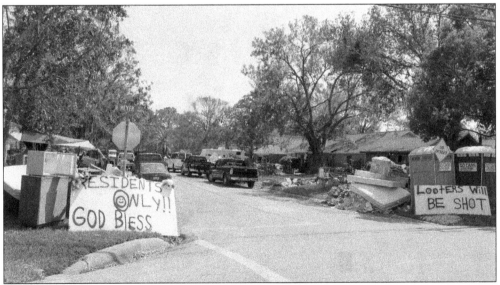

In the months after Hurricane Ike made landfall, many Seabrook residents were faced with the job of cleaning up. Years of living were displayed on the lawn. Personal belongings were laid out in the hot Texas sun to dry from the floodwaters. The process of sorting what to keep, what to fix, and what to replace were the decisions of the time.

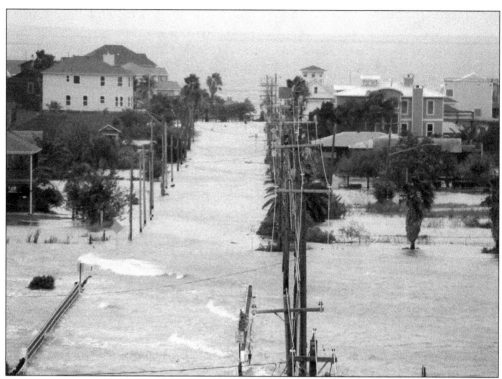

The rising water on Todville Road before the landfall of Hurricane Ike in 2008 made it hard to see where the road ended and Galveston Bay started. The storm surge was reported to have reached 17 feet in this area. (Courtesy City of Seabrook.)

The boards on Pine Gully pier were missing after Hurricane Ike in 2008. This photograph shows the pier being rebuilt in 2009. (Courtesy City of Seabrook.)

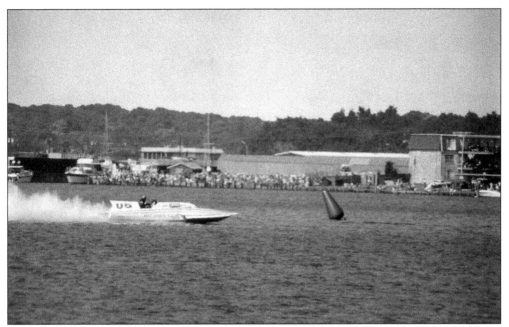

Beginning in 1975, the Red Adair North American Marathon Championship races were held on Clear Lake. It drew racers from California, Florida, Oklahoma, Arizona, Alabama, Louisiana, and Texas, as well as spectators from all over the country.

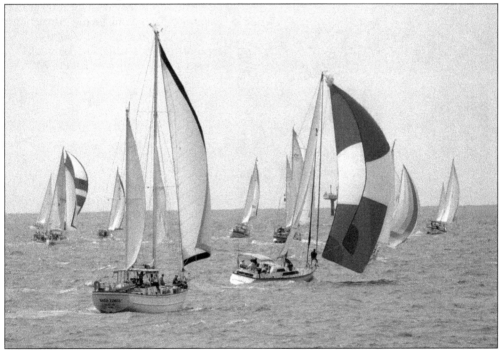

Lakewood Yacht Club's Harvest Moon Regatta begins at the flagship pier in Galveston, as shown in the photograph. The race starts at 2:00 p.m. on Thursday, and sailboats must cross the finish line before 5:00 p.m. on Saturday. Each boat is to race a distance of 153 offshore nautical miles through the Gulf of Mexico from Galveston to Port Aransas, Texas.

Levie Horton is shown on location at the Lakewood Yacht Club giving instruction on using a grey card to calibrate the exposure on your camera at Seabrook's Coastal Photo Workshop held in 2008.

The Lucky Trail Marathon began in 2003, drawing around 1,400 participants. It is held each year at Mcador Park in March, attracting people from all over the United States. They race on the nature trails throughout Seabrook. (Courtesy City of Seabrook.)

These photographs show students from the 2008 Coastal Photo Workshop, held in March, with local photographer Ruth Burke. This is one of the best months to photograph in Seabrook, and one of the best places is located on the Great Texas Coastal Birding Trail between Galveston and Houston. Flocks of regal American white pelicans spend their winter along the coastal area of Seabrook from October to April. Majestic trees are budding, and the coastal marshes are flush with new growth. Adding to the photographer's dream location are brilliant sunrises, grandiose sunsets on the water, and the seaside character of working shrimp boats offering the fresh catch of the day. Students are shown photographing on location at the Seabrook Marina and along the Seabrook Flats.

Visit us at
arcadiapublishing.com